Hau Pei Jen

Bold Horizons in Ink and Color

侯北人:

水墨丹青

Julie Holding

AuthorHouse™
1663 Liberty Drive
Bloomington, IN 47403
www.authorhouse.com
Phone: 1-800-839-8640

First published by AuthorHouse 3/23/2010

ISBN: 978-1-4490-9679-3 (sc)

Library of Congress Control Number: 2010903690

Printed in the United States of America
Bloomington, Indiana

This book is printed on acid-free paper.

authorHOUSE®

Dedication

I dedicate this book to the American Society for the Advancement of Chinese Arts (ASACA) and to its Chairwoman Theresa Lin.

我將此書獻給美國中華藝術學會及其現任會長林萬致第女士。

Contents 目錄

Forward

Defying the Limits: The Work of Hau Pei Jen

Hau Pei Jen is a legend in the northern California Chinese community. For decades he has devoted himself to art starting with traditional Chinese painting techniques and eventually creating the breakthrough that established his own unique style. Today at ninety-three years of age, he continues to challenge himself and push the boundaries of traditional painting, eastern and western.

Researching Chinese art history, one can see many evolutionary changes in ink painting since the time of Wang Wei, the first great ink-painting master of the Tang Dynasty. Ink painting first developed into two different expressive styles namely *xiao xie'i* (minimum expressive) and *da xie'i* (bold expressive). Later *da xie'i* branched out into two types of art: literati painting and Chan (Zen) painting. The more untrammeled *da xie'i* has also been called *po mo* (splash ink painting), but it actually relates more closely to the style called "break ink," which emphasizes the function of brush strokes in the interaction between ink and water on rice paper. In the mid-twentieth century this style further developed into "modern splash ink-and-color" painting, different from the previous style that relies on the brush to break the ink. For the new splash ink-and-color painting, the artist can directly pour or splash ink and color onto paper or silk and then move the paper or silk to guide the flow of the ink and color. At the critical moment of dryness, the artist may turn the ink and color traces into a landscape of mountain and clouds, and then finish it by adding the detail work of trees, small figures, houses or boats.

This style was started by Zhang Daqian (Chang Dai-chien) in the 1960s. Zhang had many followers but none of them was able to surpass the standard of classic aesthetics set by Zhang. On his solid foundation of traditional ink painting, Hau launched "splash ink and color" into the modern art world with his daring and adventuresome spirit. In recent years, he has utilized bold red, blue, green and black colors, interweaving them to create large-scale, masterful landscapes giving viewers fabulously amazing experiences.

Through decades of hard work, Hau has not only propelled his art forward; he also contributed significantly to the realm of art education. He has taught hundreds of students benefitting and enlightening them. Julie Holding, one of his outstanding students, has taken on the laborious effort of researching, organizing, and writing this book. It should further solidify Hau's contribution and preserve it for future generations.

About the author: Julie Holding was born in Beijing and educated in Taiwan. She graduated from the National Taiwan University with a bachelor's degree in electrical engineering. She went on to attend graduate school in the United States, receiving master degrees from the University of Michigan and Stanford University Graduate School of Business. She enjoyed a long career in the high-tech industry of Silicon Valley but has a long unfulfilled quest for art. After raising a family, she went back to school to study art. She took fundamental art classes at Foothill College, then studied oil painting and design at the Pacific Art League in Palo Alto. Eventually she joined Hau's Chinese brush painting class at Pacific Art League. Her work has been exhibited in China and the United States in both solo and group shows.

SAN JOSE STATE UNIVERSITY
SAN JOSE, CALIFORNIA

ARTHUR KAO
PROFESSOR OF ART & DESIGN

前言一

 侯北人先生在美國北加州華人社區，是一位傳奇性的人物。他數十年不斷從事繪畫創作，從古法到創出自己的風格；今已是高齡九十有三，仍繼續大膽挑戰自己，也挑戰中西藝術傳統的局限。

 考中國水墨畫的發展，自唐朝王維以來不斷演化，延生出小寫意、大寫意。大寫意又有文人畫和禪畫。比較豪放的大寫意又被稱為「潑墨畫」，其實是一種「破墨畫」。二十世紀中葉又發展出「現代潑墨潑彩」，它不像以前的純筆觸破墨法，而是真正將墨和彩潑灑在紙或絹上，使之自由流動，畫家也可以提起紙、絹引導彩、墨的流向，然後把握關鍵時刻，把紙、絹上的墨彩形塑為山水，再補上一些小人物、屋宇或小船。此法由張大千開始，其後追隨者不少，但總未超越張氏古典水墨美學的底線。侯先生大膽以冒險的精神在其堅實的古畫基礎上，將潑墨潑彩推進現代化的境界。近年更以大塊紅、藍、綠與黑交錯造景，完成許多巨幅山水，讓觀者驚奇感動。

 他這數十年的努力，不只讓自己的藝術往前奔馳，同時也在藝術教育方面做出極大的貢獻，加惠無數學子。今有高足黃春麗不辭辛勞，匯集資料、撰著此書，更可將其一生的貢獻留芳青史。

 黃春麗是侯北人先生的得意門生。出生於北京，在臺灣成長受教育，畢業於臺灣大學電機系。後來赴美留學，先後獲得密西根大學資訊控制系和史丹弗大學商學院的碩士學位。一生大部分時間是在高科技領域奉獻，但是她自幼喜愛繪畫，因此待子女成長之後，她毅然回學校去學畫，從基礎課程開始。先是在 Foothill College 學西洋畫，接著是到 Pacific Art League in Palo Alto, California 去學油畫和平面設計。最後轉跟侯北人先生學中國水墨畫。她積極追求幼年時代沒有機會完成的藝術夢。現在她已經能開心地享受西洋油畫和中國水墨畫的美。她的作品在美國和中國各地的個展和聯展中展出，頗受好評。這次騰出時間完成這本有學術和教育意義的著作，更是懿德可嘉。

<div style="text-align: right">

高木森

美國加州聖荷西大學教授

</div>

Hau Pei Jen's Work: A View from the Summit

"Mr. Mi will laugh at me and call me a crazy old fool."

This was inscribed on Hau Pei Jen's 2008 painting, *Mi Mountain* (fig. 4-2). The painting is done on the back side of a square sheet of Japanese gold-speckled paper less than two feet on each side. It has three or four mountains in the far distance. In the foreground are seven or eight trees. Water mixes with ink and dots follow lines as if naturally formed. Light ink breaks through dark and dark intertwines with light.

Long ago, "Mi-style" landscapes were described by scholars as essentially "bits and pieces of mist and clouds, loosely drawn, maintaining an innocent spirit" where "spring rain has just stopped, and above the river and mountains, mists are rising, hills are fading and the trees are half-hidden." Haven't they described Hau's painting? But, in Hau's painting between the far mountains and near trees, a wide ribbon of splashed red leaps as if the mountain is on fire. Besides the interaction of ink and water, there is also the interplay of ink and color: the ink is urging the color and color awakens the ink. Suddenly, we realize that the classical description of "simple, light and innocent" is not sufficient in describing Hau's painting.

The Sung Dynasty's Mi Fu and his son Mi Youren made famous a style of painting called "Mi's Landscape." Their influence is a magical umbrella extending over the Yuan, Ming, and Qing Dynasties as well as the Republic enthralling and encouraging many talented artists to bow their heads in deep appreciation of this particular style. It was not until the 1950s and 1960s that a few individual painters began modernizing classical ink painting. On mainland China, Huang Binghong was the leader in spirit gathering talents such as Li Keran and Zhang Ding. Outside of China, three innovative artists emerged: Zhang Daqian, Liu Guosong, and Hau Pei Jen. Among these three, Hau is unusual. He was a student of Huang Binghong in his younger days and was deeply shaped by Huang's theory of art. Hau, in his middle years, was also influenced by Zhang, a good friend of his. Hau has lived in Old Apricot Hall as he calls his home in Los Altos, California, for over half a century. Fame and money are like passing clouds to him. He pursues art continuously and untiringly. Approaching the age of 94, Hau is still painting. Compared to Zhang Daqian who at the age of sixty suffered from an eye illness that made it difficult for him to distinguish green from blue, Hau's good health has been a lucky circumstance for the art world. The color and form of his work is fresh and beautiful, and its spirit vigorous and solid. While graced with simplicity and innocence, his paintings are also colorful and daring. The *Mi Mountain* painting mentioned above encapsulates his style and philosophy.

In recent years, due to the Hau Bei Ren Art Museum's diligent efforts, museums in Beijing, Shenzhen, Nanjing, and Shanghai have exhibited Hau's work. In July 2009, Hau also had a major exhibit at the Silicon Valley Asian Art Center. Each exhibit generated strong and positive responses with nods from experts and the public alike. In recognition of Mr. Hau's accomplishments a book on his life and the influences of his work would be a welcome addition to the documentation of this master's historic place in the art world.

Julie Holding has been a student of Hau for three years. Inspired by Hau's innovative and diligent spirit, she began this project. She searched the archives at Stanford University and local Asian libraries, collected and studied comments from experts across both continents and synthesized notes from numerous lectures and demonstrations. Holding's command of English and Chinese has enabled her to serve as a translator both oral and written for Hau in many seminars

and key occasions. Her understanding of Hau's artistic philosophy and art theory has been enhanced by this experience.

In the appreciation and authentication of Chinese art—and for that matter any visual art—first-person observation is an important element. It is rare to be able to see an artist creating a masterpiece. Such first-hand observation affords the viewer the ability, later, to speak to the authenticity of the painting. It can also aid a perceptive viewer in contextualizing other works by the same master. Authentication experts of different times and places have struggled to "reverse engineer" or rediscover the processes employed when artwork was originally created. So, it is fortuitous and an occasion of great moment to be able to observe a master at work, as Holding and many of Hau's students had the opportunity to do in 2009 at Asilomar Conference Center in Pacific Grove, California. She is sharing her good fortune in these pages with the readers of this book.

Shu Jianhua
Curator, Silicon Valley Asian Art Center

前言二

"米家笑我老顛狂"。

這是侯北人先生 2008 年的一句題畫詩 (fig. 4-2)。那幅畫是畫在一張不到兩尺見方的日本金箋卡紙的背面，遠山三四巔，近渚七八樹，水和墨，點與線，渾然天成，淡破濃，濃破淡，都是恰到好處。前賢所講的"米家"山水的骨髓："點滴煙雲，草草而成，而不失天真"，"春雨初霽，江上諸山雲氣漲漫，崗嶺出沒，林樹隱現"，不就是這樣嗎？然而，在侯老的畫裏，遠山和近樹之間，還有一片潑出來的嫣紅，像火燒雲似在那裏橫亙著！水墨的濃淡相破之外，更有墨和彩之間的墨催彩、彩醒墨。這時候，我們才猛然覺得，面對侯老的畫，"平淡天真"的經典評語已經不夠用了。

因宋代米芾、米友仁父子而得名的"米家山水"，在中國水墨繪畫史上的地位和影響，像柄法力無邊的魔傘，元、明、清、民國，無數才人都低頭。直到 20 世紀五六十年代開始，稍有人出來張望，傳統水墨現代化才正式出現。在中國大陸，以黃賓虹為精神領袖，彙聚了李可染、張仃等眾多的才俊。在海外，則出現三位代表性的畫家，一是張大千，二是劉國松，三是侯北人。在這"海外三家"中，侯先生是比較奇特的。他早年向黃賓虹學過畫，深受其畫學思想的影響；中年時又是張大千的知交，張大千後期的變法，對侯老是有過感召的。半個多世紀來，侯先生安居于加州的老杏堂，富貴浮雲，丹青不老，如今九十四歲矣，依然能自己駕車，優遊藝事，相比花甲之後困於眼疾、不能細辨石青、石綠的張大千，真是藝術史上一大幸事，也是一大盛事。他的作品，色相求其新美，而魂魄自固渾厚，平淡天真之中，復有五彩斑斕之致。上面講到的那幅《米家笑我老顛狂》的小畫，恰是侯老繪畫風格和畫學思想的一個縮影。

近年來，由於江蘇昆山侯北人美術館的努力，北京、深圳、南京、上海等很多著名的美術博物館都有侯老的畫展，硅谷亞洲藝術中心也在 2009 年 7 月間舉辦過侯老的大展，每次展覽，都對觀眾和專家產生強烈震撼力，效果遠遠超過"群眾點頭，專家鼓掌"。唯一遺憾的是，與張大千和劉國松相比，有關侯老的傳記、評傳還沒有。現在這本《水墨丹青：侯北人》可以滿足大家的缺憾。

本書作者黃春麗女士三年前隨侯老學畫，對侯老煦和寬厚的人格、絢麗大氣的畫風和勇猛精進的精神有深刻的體驗，萌發了寫作本書的念頭，梳理侯老藝術發展的脈絡，彙編海內外專家學者對侯老藝術的評論，記錄侯老教學上許多精粹的言談和思想，並且展示侯老繪畫獨特的技法。為了本書的寫作，春麗女士在課內特別用心之外，課外也花費大量時間查找資料，甚至去史丹福大學胡佛研究中心和東亞圖書館查找出侯老早年的著作。春麗女士還有超詣的英文水準，在許多重要的展覽和研討會中，她一直擔任侯老的口譯和筆譯，她對侯老繪畫理念和思想的瞭解，又是深入一層。

在中國書畫的鑒賞中，"現場感"是一個很重要的因素。有機會現場看到一位畫家，尤其是名家和大家在創作，是件很難得的事情。日後，他（她）對這位畫家的這一件作品就有毋庸置疑的鑒別能力，如果悟性好的話，對這位畫家的其他作品也會獲得很高的鑒別能

力。很多研究專家、鑒定專家在異時異地的情況下，苦心所求，也正是想竭力還原作品創作過程、回到"現場"而已。所以，在現場，還是件很幸福的事情。春麗女士就是幸運者。她的這本書，就是和大家分享她的幸福。

硅谷亞洲藝術中心館長　舒建華
2009 年 12 月

The Gift

On September 5, 2009, over the Labor Day long weekend, members of American Society for the Advancement of Chinese Arts (ASACA) commenced their biannual retreat and workshop at Asilomar State Park in Pacific Grove, California. The day was beautiful and clear with a typical California blue sky. Waves splashed gently along the coast. Evening lights were soft and vivid. The expressive Monterey pines that had inspired so many artists in the past stood tall over the ASACA members. The time was a few minutes past six o'clock. We had just finished a simple, yet delicious, meal at the Crocker Dining Hall and were strolling leisurely towards the Evergreen Conference Room where we were to gather for a welcome and introduction for the Society's retreat.

Years 2008 and 2009 had been exciting ones for our club. In 2008, Mr. Hau Pei Jen—the founder and Honorary Permanent Chairman—completed a series of critically acclaimed splash ink-and-color landscape exhibits in four major cities in China: Beijing, Nanjing, Shanghai, and Shenzhen. In November 2008 students of Mr. Hau also held a well-received exhibit in Kunshan City in China.

Two thousand and nine marked the thirtieth anniversary of the founding of ASACA, and was no less eventful. It kicked off in February, with Hau as the featured artist for the inaugural exhibition at Euphrat Museum in DeAnza College in Cupertino, California. He received a Certificate of Recognition from the mayor of Cupertino for his contribution to the community in the field of art and education. In June, ASACA celebrated when several of its members took top prizes in the annual Audio-Visual Art competition held in Pioneer Park in Mountain View, California.

In July Mr. Hau held an exciting solo show at the Silicon Valley Asian Art Center. In August a show in the same gallery exhibited the work of his students and members of ASACA. A catalogue of the exhibit commemorated the special thirty-year anniversary of ASACA.

We had had a strenuous two years; although greatly inspired we were ready for a little rest. Settling into this beautiful California State Park and Conference Ground, we looked forward to relaxing and savoring the fruits of our labor. Merry chats and laughter were expected.

We were surprised by what the weekend held in store. Hau had a different idea for celebration. While the 2008 China exhibits and accompanying seminars brought primarily awe and praise for his art, they also brought forth whispers of disbelief. Some said his paintings could not be done with traditional methods and some claimed that he used acrylics to create his saturated and vibrant colors. In his regular weekly classes, between reviewing and critiquing students' homework, giving lectures and performing demonstrations, there was never enough time to show us how a large-scale, splash ink-and-color painting was done. In the workshop at Asilomar, Mr. Hau wanted to demonstrate his method of painting from blank sheet to near-finish. With two-and-a-half days, he thought he would have enough time to show us the full process. After a brief introduction, he set to work.

What an amazing two-and-a-half days it was, jam-packed and intense. We saw him, beginning with a blank sheet of ordinary Chinese paper and standard Chinese painting materials, build up the image, layer by layer. At each step he would explain the "what" and the "why" of his actions. He would frequently pause and ask eagerly if we understood him or if we had any questions. I was moved that night and for the rest of the weekend. I don't know which touched me more: the excitement of seeing a strikingly beautiful painting emerge from nothing or his earnestness and genuine desire that we comprehend what he was passing on to us.

A couple of weeks after the workshop, as I organized my notes, I re-experienced the workshop. I suddenly realized how fortunate those of us who were present at the workshop had been. We had the rare opportunity to witness the master at work creating an authentic Chinese painting in the unique style of splash ink and color.

Hearing many times the lament of those members who missed the workshop, I began to ponder the idea of a tutorial for Mr. Hau's splash ink-and-color technique. I shared my notes and discussed the idea of a book with Mr. Hau. He gave me his permission to proceed. Soon after I began writing with grateful, humble, and determined effort. I hope this book will serve as a tool for those interested in splash ink and color and that it will also provide a glimpse of what we had been so privileged to witness in our Asilomar workshop.

JULIE HOLDING

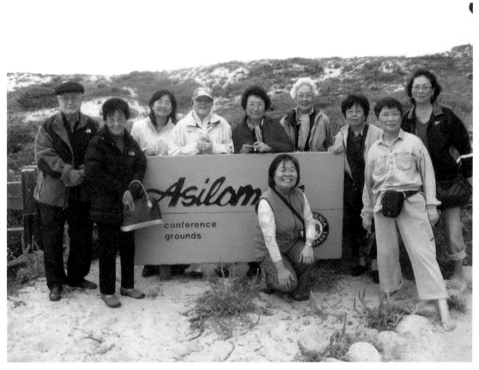

Left to right: Hau Pei Jen, Mary Hau, Susan Chan, Theresa Lin, Isabella Yeh, Margaret Yung, Josephine Li, Alberta Wang, and Amy King. In front of the sign: Julie Holding.

意外的禮物

2009 年九月五日，美國中華藝術學會在加州美麗的阿斯樓馬州立公園，舉行每兩年一度的寫生度假研討會。那天的天空是加州常有的清藍。浪花溫和的衝擊着岸邊。近黃昏的光線柔和又生動。傳神的蒙特里松樹，像往日啟發其他藝術家一樣，也高聳在上，招引着我們。我們這些美國中華藝術學會會員借着美國勞工節的週末長假，在永久名譽會長侯北人先生領導下到這裡來寫生度假。這時六點剛過，我們剛吃過了一頓簡單但可口的晚餐，正循着以往慣例，悠閒的漫步去長春會議廳。準備出席七點鐘的介紹會。

2008 和 2009 對我們學會來說是忙碌又多采多姿的兩年。除了侯會長先後在深圳、南京、北京、上海及硅谷舉辦了成功的個人展之外，又在昆山和硅谷舉行師生聯展。2009 是美國中華藝術學會成立三十週年。在這人天同慶的紀念年，我們學會更有些突出的活動。首先今年二月舊金山灣區有名的笛安札學院邀請侯北人先生為他們 Euphrat 博物館開舘展的首席畫家。三月中，加州庫柏蒂諾市市長頒給了侯北人先生一份褒獎狀獎勵侯先生對社區文化及教育的貢獻。六月初，我們學會幾位會員在一灣區繪畫競賽年展中奪了數項大獎。七月，我們又為三十週年師生展出了一本畫冊。這些活動讓我們忙得雖興奮但也有些倦了。今天比以往更期待這兩年一次的阿斯樓馬寫生度假。大家想像的這兩三天是會同以往 一樣的有一個愉快的寫生聚會。

我們沒人預料到侯老師另有想法。他要利用這兩天半的時間，教我們一些平時每週兩小時學不到的東西，他要教我們從白紙畫到完成的潑彩山水畫的整體過程。由於侯老師用的是積彩程序，顏色是一層層累積上去，一張畫要經過多次由濕到乾的過程，把握時間很重要。所以我們每人儘快地，做了簡短的自我介紹後，侯老師就立刻開始教課。他先把理論解說了一遍，隨後即時示範。他用的是宣紙一張，瓶裝墨汁及管狀國畫水彩原料。就這樣開始創作。一直畫到九點多鐘達到他預期的效果後才停止，讓畫有機會風乾為明早做基底，更加一層的繪製。

接下來的兩天過得很緊促。潑彩、勾勒、風乾反復了三、四次。每個關鍵點侯老師又仔細講解他所做的步驟及原理。一次次他停下來熱切的問我們明白了嗎？當晚我很激動。不知是因為見到美麗的畫面在老師手下產生，還是老師恨不得立時教會我們及他誠摯認真的眼神，更讓我感動。

從阿斯樓馬回來後，有天我在整理筆記之時突然意會到我們參加了這次寫生會的人，有多幸運能見到大師創作的全程。許多沒能參加的同學時時哀嘆失去良機。聽多幾次後我不禁自不量力的想把筆記整理成書，希望能借此減低他們的遺憾，更希望將侯老師技法介紹給更多有興趣的朋友。我將此意請示侯老師。幸得他贊同，因此提筆來寫這本書。

黃春麗

Acknowledgements 謝詞

I especially want to thank Hau Pei Jen and Kunshan Hau Bei Ren Art Museum, San Jose State University Professor Arthur Kao, and Silicon Valley Asian Art Center Curator Shu Jianhua for making available to me many of the articles and photos used in this book.

Photo credit of Dunhuang artifact images goes to Dunhuang Research Academy; the cover portrait to Wesley Zhang and cover design to Shan Liang.

ASACA Chairwoman Theresa Lin's encouragement and support gave this project the necessary fuel. Additionally, her gift of the Chinese input device and software Penpower Jr. allowed me the means to type in Chinese.

I give a deep bow to my edit and proofreading team: Patricia Machmiller, Chen Suchaio, Alberta Wang, Margaret Yung, and Laurel Holding. They are my quality assurance advisors. Coming from the high-tech world, I appreciate the value of quality assurance; they make the product functional and user friendly.

And last but not the least, a thank-you to Jay Houston whose advice on the structure of the book and on finding my voice was most helpful.

首先要特別感謝畫家侯北人先生和昆山侯北人美術舘， 聖荷西加州大高木森教授，及硅谷亞州藝術文化中心舒建華舘長提供本書許多參考資料。

敦煌文獻畫面來自敦煌研究學院，侯北人先生的封面照歸功於 Wesley Zhang，封面設計由 Shan Liang 主筆。

美國中華藝術學會現任會長林萬致第女士的啟發，鼓勵及支持帶給本書激動力。 她提供的小蒙恬解決了作者中文輸入的難題。

此書審核校正由白翠霞，陳淑嬌，戴天禾，卜篦年，及 Laurel Holding 共同完成。作者在此向她們深誠的一鞠躬。

作者向 Jay Houston 致謝，他的建議及指引幫助作者找到本書的結構、組織、及論點。

Part I

Chapter One: Introduction
第一章 引言

The time was June 23, 1984, and the place the Chinese National Fine Arts Museum in Beijing. The air was full of excitement, despite being wet from a steady drizzle. Crowds lined up around the block patiently waiting in the rain to see the art exhibit of Hau Pei Jen (see fig. 1-1). Hau was one of the first nonresident Chinese artists to hold a solo exhibit in China. Critics wrote that his colorful, vibrant, bold, and expressive images were like a breath of fresh air. For days, the lines continued; the public liked what they saw.

Fig 1-1 *1984 Beijing exhibit*

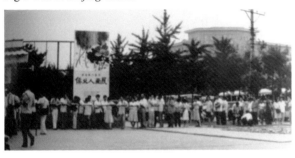

Twenty-four years and twenty solo exhibits later, Hau returned in 2008 and exhibited again in Beijing. During the same year, his work was also exhibited in Shenzhen, Nanjing, and Shanghai. Art critics and historians recognized Hau's splash ink-and-color method as representing a new direction for Chinese art[1].

A year later, in 2009, Hau had a solo show in Silicon Valley Asian Art Center in Santa Clara, California. It was also very well received. Art collectors praised Hau as a first-class artist in the international arena.

Who is Hau Pei Jen? What is unique about his art? Why has he been received so successfully

1984 年六月，侯北人是首批海外畫家在北京舉辦個人展之一。展出時適逢北京六月常見的下雨天。人們不因下雨而避開這畫展，反而淋雨排隊爭先的等着看他的畫 (fig. 1-1) 。 1984 年 6 月 30 日的*團結報*畫評說他的畫豪放、重彩、筆墨淋漓、意境清新、且富有時代感。當年中國美協副主席華君武也稱贊他的畫既有中國傳统風格，又有創新，很新鮮。

二十四年及二十次國際個人畫展後，侯北人於 2008 再次回到北京展出。並於同年也在深圳、南京、和上海作巡廻展。這一系列的畫展再次帶來轟動。畫家、學者、和專家們認為侯北人代表中國畫的新方向[2]。

2009，侯北人在美國加州硅谷舉行個人展。收藏家爭先讚美他的畫為世界一流的畫作。

誰是侯北人？為什麼他能這麼成功，為什麼他能讓大眾市民、專家、和收藏家都如

[1] Additional details in Chapter Three.
[2] 細節見第三章

by the public, art critics, and collectors alike?

此欣賞他的畫？

Hau Pei Jen was born in 1917 in Liaoning, China.　He came from a scholarly family. His great-grandfather was an Imperial Scholar. From the age of six he began studying poetry, calligraphy, and painting with his grandfather. He attended high school in Baoding and university in Japan, graduating from The Nine Provinces Emperor University in Kyushu in 1943.　While in Baoding and Beijing, Hau began writing for magazines such as *Beijing Chinese Literature*.　He moved to Hong Kong and lived there from 1948 to 1956, working as an author and artist.　Under the pen name Duanmu Ching, he published essays and novels. Two of his books from this period are in the collection at Stanford University's Hoover Library; see fig 1-2 and fig 1-3.

侯北人原籍河北省昌黎縣。1917 年生於遼寧省海城。高中肄業於海城營口保定後留學日本九州帝國大學。曾祖父為國子監大學士。自幼隨祖父學習書法及詩文。中小學時已對繪畫專注投入。在北京及保定期間也開始從事寫作。作品發表在北京中國文藝等刊物上。

1948 年，遷居香港後，仍繼續從事寫作及繪畫，曾以筆名端木青出書。至今仍有兩本他的著作收藏於史丹福大學的胡佛圖書館。見圖 1-2 及圖 1-3。

Fig. 1-2 *Spring of Home Land*　　　　　　Fig. 1-3 *Ahbahahaerchi Prairie*

In his early years, he studied painting under Li Zhongchang.　Later he took instruction from the modern masters, Huang Binghong (1865 – 1955) and Zheng Shiqiao.　In 1956 he moved to the United States.　After settling in Los Altos, California, a small town forty miles south of San Francisco, Hau focused on art and art education.　He has taught Chinese watercolor painting to students of all nationalities at the Pacific Art League for fifty-two years.　He is respected by colleagues and students alike.

侯先生早期師從李仲常，後又隨黃賓虹及鄭石橋二位大師學畫。1956 年移居美國。從事藝術及藝術教育工作五十年如一日。有教無類的在太平洋藝術聯盟教授中國畫，備受同仁及學生們的敬仰與愛戴。一位太平洋藝術聯盟同事及名戰場速寫及法庭速寫專家 Howard Brodie [4] 對侯先生非常的敬仰，曾為侯先生畫像 (fig. 1-4) 並題詞"送給一位優美的藝術家"。

Howard Brodie[3], an award-winning combat and courtroom sketch artist and fellow instructor at the Pacific Art League, made a sketch of Hau. The inscription on the sketch "For the beautiful painter Paul Pei Jen Hau" showed the affection and respect he had for Hau (fig 1-4).

In July 1979 after the Unitied States and People's Republic of China established diplomatic relations, Hau founded the American Society for the Advancement of Chinese Arts (ASACA) to facilitate the cultural interchange between the two nations.　He was elected the first chairman and later the Permanent Honorary Chairman of ASACA.

1979 年中美建交。為促進中美文化交流，侯先生與數位同道成立美國中華藝術學會，並被推選為首任會長，之後又被推選為永久名譽會長。

Over the past thirty years, under the leadership of Hau, ASACA had conducted many art exchange activities including, but not limited to, art and calligraphy exhibits, visits and seminars of accomplished artists from China such as Zhu Qizhan, Wong Qichien, Zhang Jianzhong, Xu Shan and Zhao Zonggai, to name a few, and art interchange tours for American artists.　These artists visited major Chinese art institutes and associations, participated in joint art activities, toured art centers and museums, visited famous sites such as Beijing, the Great Wall, Yellow Mountain, Guilin and the ancient capitals of Nanjing and Xi'an.　These trips gave ASACA members not only the opportunities to appreciate the glory of Chinese landscape but also to gather materials and inspirations for their artwork.

三十年來在侯先生的領導下，美國中華藝術學會舉辦過多次有關藝術交流活動。除了多次書畫展外，也邀請中國名畫家包括朱屺瞻、王己千、張建中、徐善、趙宗概、…等十多位到會中講演及示範。也曾多次組團訪問中國與藝術院校及團体交流繪事，參觀美術舘及博物舘，並遊北京，登長城，寫生黃山，訪桂林及古都南京、西安等地。讓會員們領略了大陸的景觀風采，攝取了作畫的無限素材，獲得了行萬里路的豐厚果實。

[4]他的戰場作品曾得獎並多次選登*美國*人雜誌封面，也曾為許多有名的法庭審案作畫
[3]Brodie's war sketches were seen on *Yanks Magazine* covers and collected in *Drawing Fire*.　His courtroom credits included famous trials such as *The Chicago Seven, Charles Manson, General Westmoreland, The Ruby Trial,* and *Senate Civil Rights Debates.*

Fig. 1-4 *Beautiful Painter*

For the beautiful
painter Paul Bei-Jen Hau

Brodie
'77

In 2002 Hau donated his rare collections of past masters such as Zhang Daqian, Fu Boashi, Zhu Qizhan, and Huang Binghong as well as more than three hundred pieces of his own work to the City of Kunshan, Jiangsu Province, China. The People's Government of Kunshan City built a museum in his name (Hau Bei Ren Art Museum) to house these works. Hau Bei Ren Art Museum is an active museum. In addition to regularly scheduled exhibits of Hau's collection, it has also invited accomplished artists from other countries to exhibit their work and conducted international art exchange seminars. Starting in 2008, Hau Bei Ren Art Museum also began touring major cities of China exhibiting Hau's work.

 Hau's works have been exhibited in and collected by major museums and universities internationally, including De Young Memorial Museum, San Jose Museum of Art, and Museum of Modern Art, Vienna, Austria.

Hau has published over ten art books with collections of his paintings. Below (fig. 1-5) are two of his latest books.

2002 年侯北人先生將他一生傑作及他收集的名家如黃賓虹、張大千、傅抱石、 及朱屺瞻等人作品,共三百餘件捐贈給昆山人民,昆山市政府為他建立了侯北人美術舘以收藏之。 除了定期展出舘內收藏之作品,侯北人美術舘也經常邀請中外名家展出並促進國際藝術交流。 自 2008 年開始,侯北人美術舘又將侯北人作品在中國各大城市巡迴展出。

侯先生的作品有過多次成功的個展,並被收購於國際博物舘如美國舊金山地揚博物舘,美國加州聖荷西美術舘,及奧地利近代藝術美術舘.

侯先生曾出版多達十餘本畫冊. Figure 1-5 為最近作品之例.

Fig. 1-5 Selected Paintings of Hau Pei Jen and *Hau Pei Jen Landscapes*

However, he has not published a book on methodology. This is the first book concerning Hau's unique methods.

Hau's student body is international in nature with many who do not understand Chinese as well as some who are not comfortable with English. In order to broaden the readership, this book is written in English and Chinese both. It is intended to be an intermediate-to-advanced-level method's book. They say, of course, that a picture is worth a thousand words. Convinced of the effectiveness of visual learning, this book used less text than other methods' books and has emphasized pictorial instructions. This book is structured in two parts. Part 1 discusses Hau and his art and contains four chapters. Chapter 1 is an introductory chapter summarizing Hau and his artistic achievement. Chapter 2 is on the historical development of splash ink and color and brings forth Hau's contribution in this technique. Chapter 3 outlines Hau's artistic characteristics leveraging on commentaries of art professionals and visionaries. Finally chapter 4 discusses Hau's unique style based on his students' study and analysis.

Hau possesses excellent traditional Chinese painting techniques synthesized with modern vision and application. Among all his accomplishments, he is known widely for his achievement in splash ink and color. Therefore, the second part of the book is dedicated to the step-by-step development of a full scale splash ink-and-color landscape, which Hau painted at the ASACA 2009 workshop in Asilomar.

Finally, a word on the conventions used in this book. I follow the modern convention in translating Chinese names: the last name first followed by first name. If the person's first name has two characters, both characters are combined into one with no space or hyphen between them, for example Huang Binghong and not Huang Bing Hong. There are two exceptions to this rule. First, if the person has

本書是第一本介紹侯先生的畫及其繪畫技法的畫冊。

侯先生的學生來自不同國籍，課堂上多由中、英語講解交流。為推廣閱讀率，本書也以中英雙語編寫。但俗話說一幅畫勝過千字文，因之本書也偏重於圖畫教學。以阿斯樓瑪坐談會示範圖片為主來解說侯先生的技法。

本書分兩部。第一部討論侯先生以及他的畫。分四章。第一章是引言簡介侯先生及他的藝術及教學成就，第二章為潑墨潑彩史解說潑墨潑彩歷史的演變及侯先生對此畫技的貢獻，第三章借用畫家及畫評家的評論講侯先生獨特之畫風，第四章是從學生的觀點來研討和分析侯先生的藝術。

第二部只有一章，示範侯先生潑墨潑彩創作方法。潑墨潑彩是侯先生最突出、最為人推崇的技法。因之此章將詳細解說侯先生潑墨潑彩作畫之步驟。

為了易於閱讀，茲將英文名字寫法解釋如下。第一循中國近代之慣例先寫姓再寫名字，名字無論長短，都拚寫成一個英文字。如黃賓虹為 Huang Binghon。但有一些例外，姓名含有英文名字的寫法是先寫名字後寫姓，如 Arthur Kao。此外，因為大家已經習慣 Hau Pei Jen 的書寫方式，侯北人的名字仍保持原

a western first name, then I follow the western convention of first name followed by last name, for example, Arthur Kao. The second exception is Hau Pei Jen. I leave a space between the two characters of Mr. Hau's first name, as many people knew him by that name.

Following the American convention, in the English text no titles are used preceding a person's name; for example, Hau is used instead of Mr. Hau.

來拼寫方式，不做任何變更。第二遵循英文慣例，書中英文人名不加稱呼，因之本書英文部，也直呼 Hau Pei Jen 或 Hau 而非 Mr. Hau Pei Jen 或 Mr. Hau.

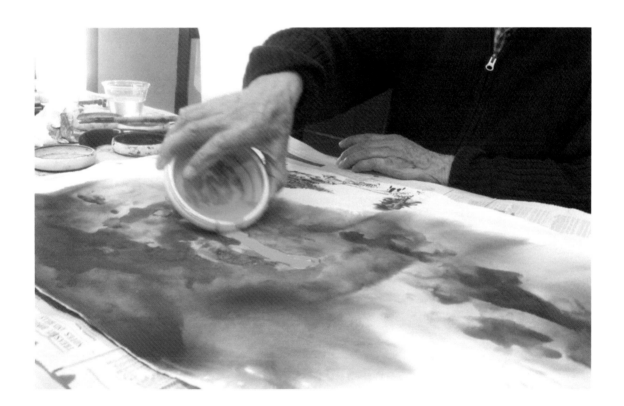

Chapter Two: Chinese Splash Ink-and-Color Art History
第二章 中國潑墨潑彩史

Splash ink and color is a key element of Hau Pei Jen's art. To understand his art, we need to start with splash ink. This chapter is developed largely based on a presentation given at De Anza College in Cupertino, California, by Dr. Arthur Kao, Art History Professor at San Jose State University, San Jose, California.

We will trace the historical development of splash ink and the cycle of color usage in Chinese art. After examining the evolution of splash ink and the use of color in Chinese painting, one can easily see that splash ink and color followed naturally when the artificial inhibition of color usage was removed. With an understanding of the historical development, we will see that the foundation of Hau's art rests with traditional Chinese painting techniques and that Hau took some of these techniques to another level and in the process cemented his unique legacy in the continuum of Chinese art.

潑墨潑彩是侯先生畫風主要元素之一。要了解他的畫需從潑墨和色彩這兩個命題開始。本章以美國加州聖荷西州立大學藝術及設計學院教授高木森博士在加州笛安扎學院的演講內容為基礎而延申討論潑墨、潑彩的演變史。由潑墨潑彩的演變史，我們可見現代的「潑墨潑彩」延續於傳統之「潑墨」畫，並由此章展示侯先生的畫是有根深的傳統國畫基楚，同時侯先生研發潑墨潑彩更上一層樓，有其獨持的成就，並對潑彩技術的開拓有很大的貢獻。

Traditional Splash Ink Painting 傳統潑墨畫

Splash ink—known in Chinese as *po mo*—was possibly first used in the Tang Dynasty (ca. ninth century). Zhang Cao painted trees on silk by holding two brushes in one hand, one brush full of ink and the other full of water. When the strokes appeared on silk, the traces displayed the interaction of water and ink. In the book *Famous Paintings of Tang Dynasty* Wang Qia was cited as another splash ink artist. Ming Dynasty artist Dong Qichang (1555 – 1636) said: "Paintings of cloudy misty mountains did not start with Mi Fu. In the Tang Dynasty Wang Qia's splash ink painting already exhibited this capability." In *Huang Binghong Collection of Art Theory* Huang described Wang's painting method saying Wang loved to drink and would get drunk

潑墨技法大概在唐朝開始，中國繪畫史曾提及張操畫樹，一手持兩枝筆，一濃一淡，畫在絹上讓墨、水互相滲透。《*歷代名畫記*》、《*唐朝名畫錄*》等史書也提及另一唐代畫家王洽以潑墨作畫。明朝畫家董其昌說："雲山不始于米元章，蓋自唐時王洽潑墨，便已有其意。".*黃賓虹畫語錄*也提到唐之王洽，潑墨成畫"每欲作圖必沉酣之後。解衣槃礴。先以墨潑幛上。因其形似，或為山石，或為林泉。" 可惜王洽潑墨流傳已失。

before painting.　Wang would pour ink onto a piece of silk; then depending on what the resulting form resembled, added finishing strokes to make it into mountains, rocks, forest or streams.　Unfortunately, Wang's method was not widely followed.

Today, the earliest examples of splash ink works available are seen in the Chan (Zen) paintings of the tenth century.　Zen painting is a form of art that uses calligraphy and ink brush painting to express Zen philosophy. The best examples are those paintings done by Shike of the tenth century and Liang Kai and Muqi of the twelfth century.　In a painting called *The Second Patriarch in Repose* (fig 2-1), Shike with a few loose and handsomely broad strokes in splash ink style painted the Zen high priest meditating on a tiger.　The painting illustrated the depth of the priest's Zen power: to be so close to danger, yet so carefree and calm.

潑墨畫現存最早的例子常見於第十世紀的禪畫。禪畫將書法，水墨毛筆畫及禪思綜合一體。最著名的代表作是第十世紀的石恪和十二世紀的梁楷和牧溪。圖 2-1　二*祖調心圖*是石恪重要的代表作。圖中畫的是禪宗祖師調心思禪時的景象。石恪以狂草的筆法用粗筆、破筆潑墨畫出，再以淡墨渲染。不經意的草草逸筆表現出高僧依虎為枕微妙深邃的禪境。

Fig. 2-1 *The Second Patriarch in Repose*.

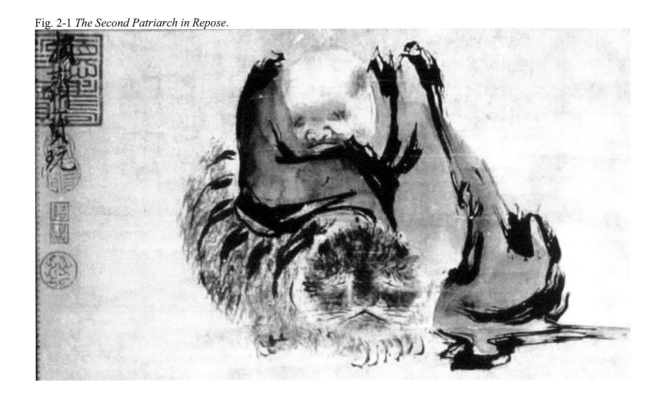

Splash ink painting saw further development in the thirteenth century in Japan by notable artists such as Kao, Mokuan and Sesshu.　In China,

這種潑墨法在十三世紀的日本畫壇上繼續發展，如可翁、默庵和雪舟等人都是著名的潑

this art form entered a new era in the Ming Dynasty[5] when literati artists such as Xu Wei and Chen Shen actively utilized splash ink in their paintings. Qing Dynasty artists Shi Tao and Bai Da are recognized for their application of this technique. Many early twentieth century artists, such as Wu Changshuo (1844 – 1927), Fu Baoshi (1904 – 1965) and Qi Baishi (1864 – 1957), were fond of splash ink painting technique.

Traditional splash ink paintings were often executed with big brushes full of ink and water. The ink spread out on rice paper along the broad stroke. Occasionally, a few drops of light ink were added to the still wet dark ink to make the ink spread out. As this traditional splash ink technique doesn't really pour ink on the silk or paper, it has also been called break ink (*po mo*) painting.

After examining splash ink development, we will move on to the second aspect of splash ink and color by looking at the history of color usage in Chinese painting.

墨畫家。中國的明朝[6]也有文人畫家如徐渭和陳淳喜歡用潑墨筆法作畫。清朝更有石濤、八大等名家擅用潑墨技法。二十世紀的畫家更多喜愛潑墨畫，吳昌碩、傅抱石和齊白石等名家為例。

傳统之潑墨是以充滿了水和墨的筆在宣紙上作畫，讓墨和水互相滲透，偶而也加幾點淡墨在仍濕的濃墨上，讓墨在有限度的範圍內擴散。因為這種技法不是真正把墨潑到紙或絹上，所以也被稱為「破墨法」。

下面我們繼續研討第二命題, 中國畫用彩的歷史。

Color in Chinese Paintings 中國畫的色彩

The colors used in Chinese painting before the Six Dynasties (fifth and sixth centuries) were limited to black, red, ocher brown and white. Additional pigments of blue and green were used after the opening of the Silk Road in fifth century. The use of new artistic materials reached its height in the Tang Dynasty. Today brilliant pictures are still visible in Dunhuang frescoes and sculptures (fig. 2-2, 2-3).

中國六朝(5 – 6 世紀) 以前的畫，所用的顏色很有限，主要的是黑、紅、赭和白。絲路於五世紀開通之後，中亞的石青、石綠等礦物質顏料傳入中原，中國畫的色彩才豐富起來。今日我們仍可在敦煌的壁畫和彩塑（圖 2-2 及圖 2-3）上看到色彩繽紛的藝術品。

[5] See Appendix I for chronology of Chinese dynasties.
[6] 參考書後附錄 I 之年代表

Fig. 2-2 Dunhuang artifact

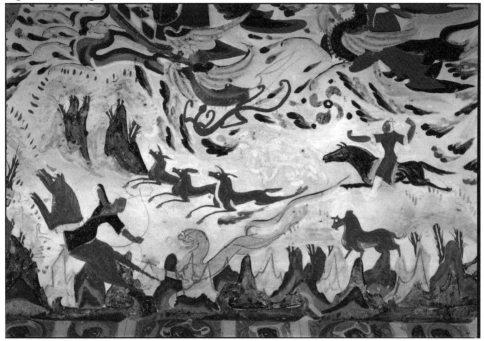

Fig. 2-3 Dunhuang artifact

After the Tang Dynasty, the Silk Road fell under the control of nomadic tribes and its culture declined.　It became more difficult and costly for the Chinese artist to obtain Central

唐朝滅亡之後西北的絲路被游牧民族控制，絲路文化也随着衰退。中亞生產的礦物顏料也因此貨奇價高。中國畫家又回到傳統以水

Asian mineral pigments. Unable to obtain
good materials for color, artists returned to ink.
From the Song Dynasty onward artists were
forced to concentrate on the art of black and
white ink paintings. Through the Yuan, Ming
and Qing Dynasty, literati ink painting was the
mainstream art in China. Ink painting was
firmly entrenched as the most respected way of
art creation. Huang Binghong noted this
historical evolution in his conversation with
Hsia Chengsho in 1952. For nearly a
thousand years, color was viewed as vulgar and
profane. Artists felt inhibited and shunned the
use of bright colors. Over time, color went
from glory in the Tang Dynasty to being an
outcast in later dynasties. The avoidance of
color persisted until the late Qing Dynasty.

墨為主的創作。宋朝以後的畫家因顏料不易
獲得而專心於畫水墨畫。歷元、明、清三代
文人水墨畫成了主流。 黃賓虹於 1952 年在
《天風閣詞學日記》中和夏承燾談水墨時也
提及：水墨畫已牢牢穩住成為最高雅可敬之
畫風。幾近千年下來彩色畫成了平凡俗氣，
畫家們羣起避之，直到晚清畫家們都避開顏
彩。因為欠缺顏料致使近千年來彩色無法進
入中國繪畫的主流。

Fig. 2-4 *Sitting on a Spring Mountain*

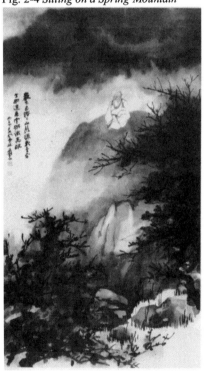

Zhang Daqian and Modern Splash Painting Techniques 張大千與近代的潑墨畫

Modern artists Zhu Qizhan, Liu Haisu (1896–1994) and Zhang Daqian (Chang Dai-Chien (1899–1983) all ventured into the realm of splash ink-and-color painting. Among them, Zhang is the best known and often credited for reviving the popularity of the splash ink technique.　While most artists stayed with the traditional splash ink technique using brushes to apply the ink, Zhang reduced the reliance on brushes and began pouring the ink on the painting surface.　He is also noted for the more active use of color.　In the early 1940s he spent nearly three years studying Dunhuang artifacts. It gave him a rich foundation and provided inspiration for the use of color. Color can be seen in his early traditional paintings done in the 1950s and 1960s.　In the late 1960s, Zhang began utilizing splash methods in his painting.　A few years later, Zhang began incorporating color in his splash technique.　Fig. 2-4, *Sitting on a Spring Mountain,* is a splash ink painting done by Zhang in the 1970s.

近代 (二十世紀) 畫家朱屺瞻、劉海粟 和張大千都繼續開拓潑墨畫。但大部份的畫家都還是以筆作畫為主,張大千更大膽大量使用潑灑的方式進行創作,故被稱為潑墨之冠。張大千於一九四零年初曾入敦煌臨壁三年,充分體悟到用色的秘訣。　他1950 及 1960 的傳统作品中開始出現鮮象色彩。60 年代晚期,張大千開始作潑墨畫。數年後更作潑墨潑彩畫。圖 2-4 是他1970 年之潑墨作品之一。

Fig. 2-5 *Tall Mountains and Long River*

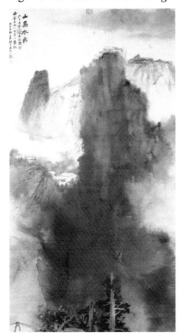

Tall Mountains and Long River (fig. 2-5) is an example of Zhang's splash ink-and-color painting.

There are many theories about why Zhang started to splash ink and color. First and most critical are his experiences in America, Cuba, India, and France where he encountered western culture. In the late 1950s, Zhang exhibited with Picasso in Paris. It is said that Picasso joked with Zhang about being unable to find Zhang's painting among the colorful western paintings. After returning from the Paris exhibit, Zhang was motivated to innovate with color. Some people also hypothesize that Zhang's failing eye sight did not allow him to work in the traditional style.

Zhang used his Dunhuang wall painting experience and silk-dyeing knowledge, which he had learned in Japan, to expand his world of ink and color. Dunhuang wall paintings used more opaque pigments of blue, green, and white; these colors when used in silk painting, allowed artists to modify their composition. From his silk-dying experience, he had seen how the free flow of ink and color brought out unexpected effects. To emphasize the splash effect, Zhang reduced the use of brush strokes. In some cases, especially in lotus flower paintings, he combined bold brush strokes and splashed ink together. The difference between Zhang's splash ink and traditional splash ink can be seen in the following aspects:
1) ink and color flow more freely;
2) the role of the brush has been reduced;
3) the paintings contain more accidental effects;
4) the paintings are more colorful and more abstract; and
5) the resulting images give viewers more visual surprises and challenges.

Nevertheless, Zhang retained traditional subjects and the classical aesthetics of harmony, balance, and intimacy.

Figure 2-5 是張的潑墨潑彩代表作之一。

有很多原因讓張大千走上潑墨潑彩的新路。首先，也是最關鍵的動力應該是受西方文化的衝擊。張大千曾旅居印度、巴西、美國、法國，體驗到西方藝術的壯觀瑰麗。當然還有其他的可能，如一說他的眼力退化不能再畫傳統的畫了，另一說他是受畢家索一席話的影響。張大千和畢加索在巴黎同展，傳言畢曾戲言，在充滿西方彩畫的展廳中，看不到張的水墨。從巴黎回來後張更致力於用彩。

張大千在他堅實的傳統水墨畫基礎上，引用敦煌壁畫及日本絲染學到的經驗與技術。敦煌壁畫使用不透明的藍、綠及白色。當這些顏色被用在絹或紙上，就可以讓畫家有機會更改構圖。而由絲染技術啟發出潑墨潑彩，就能讓墨與色自由流動，產生意想不到的視覺效果。與此同時，為了加強潑灑的效墨，張大千也減低用筆觸的分量。在畫荷時更將粗壯的筆觸及潑法共用。因此和傳統的潑墨比起來，張大千的潑墨潑彩有以下的不同之處：
　　1）墨和彩的流動更加自由；
　　2）用筆的份量減少了；
　　3）常有突發的效果；
　　4）畫更多彩多姿，並具抽象性；
　　5）畫面也常給觀畫者視覺上的驚喜及挑戰。

不過，張大千基本上嚴守著傳統的題材和古典美學的調和及平衡。

14

Hau Pei Jen and Twenty-first Century Splash Ink and Color 侯北人與二十一 世紀的潑墨潑彩

Another outstanding splash painting artist is Hau Pei Jen. Hau combined the splash ink and color technique with richer and more vibrant colors. For the rest of the twentieth century and the first decade of the twenty-first century, Hau continued to develop the art of splash ink and color. In general, Hau keeps to the traditional subject of landscapes with small figures, but unlike Zhang Daiqian, he moved away from the classical aesthetics making bold use of bright and contrasting colors and forms in his compositions. He brought aesthetics of literati painting to a new stage using free-flowing brushwork and pouring techniques reflecting his untrammeled personality to challenge traditional artistic concepts. Figure 2-6 is an example where Hau shows off the glory of a sunrise utilizing splash technique and bold color. This painting will be used in Chapter Five to illustrate Hau's technique step by step.

另外一位傑出的潑墨潑彩畫家是侯北人。侯先生引進了生動鮮艷又豐盛的色彩讓潑墨成為地道的潑彩。幾十年來侯先生不停的創新及改進潑墨潑彩的技術。一般而言，侯先生還是保留傳統的題材── 山水畫加小人物。然而，用了許多較明亮和更多強烈對比的色彩並在構圖造形上創新。 用非傳統的筆墨表現其不拘的性格，以挑戰傳統的藝術理念。以下的附圖 2-6 *山莊朝霞* 展示他新作中的這些特點。本書第 5 章將用這張畫為例，逐步講解他的技法。

Fig. 2-6 *Sunrise at a Mountain Estate*

Examples of Hau's Challenges to Traditional Artistic Concepts 侯多面挑戰美學觀念

In Hau's paintings abundant examples exist to show how he challenges traditional artistic

侯先生的畫充滿了他向傳統美學觀念挑戰的例子。 下面將研討四個這樣的例子

concepts. We will examine below four such examples in which he challenges

- the overall harmony of traditional art,
- the rational perspective of western painting,
- the rational perspective of Chinese painting, and
- the classical compositional balance.

In figure 2 -7, *Small House in the Misty Rain*, with its strong dark ink emphasizing the left side of the image, Hau is challenging the traditional concept of balance and overall harmony.

Fig 2-7 *Small House in the Misty Rain,* 18"x21", 1995

In figure 2-8 the painting, *Clear Snow and River Clouds,* is shown in its original orientation (left) and upside down (right) to demonstrate how Hau challenges the western notions in perspective that larger or more detailed objects are closer to the viewer.

- 挑戰傳統的合諧感，
- 挑戰西方透視學理，
- 挑戰國畫透視學理，
- 挑戰古典構圖平衡感。

例 1：圖 2-7 *小樓煙兩* 畫面左邊大片墨色使畫重心遍左挑戰傳統之合諧感。

例 2：圖 2-8 *晴雪溪雲* 左邊是原作 右邊倒看以符合西方透現畫理：下近上遠。近物大而且清楚有細節，遠物小而模湖沒細節。

Fig. 2-8 *Clear Snow and River Clouds,* 54"x28", 2002

In figure 2-9, *Sky with Ten-Thousand Clouds,* is shown on the left and on the right, it is reversed. While both orientations are pleasant compositions, Hau placed the negative space at the bottom as opposed to the traditional use at the top as sky. The reversed view appears to be more consistent with traditional Chinese perspective in which the main subjects are more prominent and minor subjects smaller and more vague. This painting represents Hau's way of challenging Chinese traditional painting perspectives.

例 3：圖 2-9 左邊是原作。右邊倒看似乎更近國畫透視畫理之主大賓小，主次分明。再看原作，可隱約見到侯北人挑戰傳統國畫透現原理之意。

Fig. 2-9 *Sky with Ten-Thousand Clouds,* 54"x28", 2008

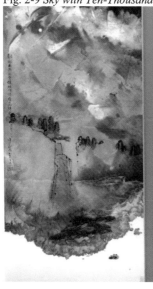

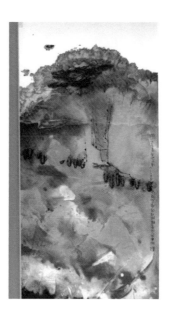

In figure 2-10, *Difficult Journey to Sichuan*, the image on the left is the original painting. On the right the painting is rotated to show the balance in a classical landscape composition with the heavier features at the bottom. In this painting Hau showed a strong painting while challenging the classical compositional balance.

例4：圖 2-10 左邊是原作*蜀道難*。右邊橫轉以符合國畫古典構圖畫理。

Fig. 2-10 *Difficult Journey to Sichuan,* 56"x30", 2001

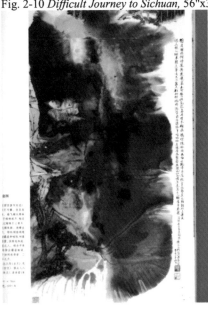

Thus, we can see Hau has brought modern splash ink-and-color painting to a new level; he challenges traditional aesthetics and explores the capacity of splash ink painting. Arthur Kao says of Hau, "Overall, he has unleashed a riotous and impassioned world full of powerful and grand dreamscapes. We may say he takes the approach of a modern artist creating a fascinating and imaginative world of his own. For years he has been teaching students ink painting; his effort has brought to the west the art of modern splash ink and color."

由上文的論述，可見侯先生把現代潑墨潑彩畫帶入一個新的境界，挑戰傳統美學觀念及探側潑墨的極限。高木森教授總結：”侯先生創造了一個強力、震懾、大氣、又夢幻的世界。也許我們可以說他由近代畫家觀點出發去創造一個有趣的夢幻氣氛。他多年教學生水墨畫，也帶給加州社區一個新「潑墨」藝術。”

Splash ink-and-color technique developed slowly throughout history. One can assert, perhaps without much objection, that major leaps in the development in this art form happened only in modern times and are the contribution of two artists: Zhang Daqian and Hau Pei Jen.

潑墨潑彩在歷史中經過千年緩慢的演進．和前面千年比較，最近五十年進步神速。應歸功張大千及侯北人。

18

Chapter Three: The Art of Hau Pei Jen–View of the Experts
第三章 專家看侯北人的畫

What is unique about Hau's painting?　Some frequently noted characteristics include his bold use of vibrant colors, and energetic, refreshing composition.　In the previous chapter, we discussed the use of the splash ink-and-color method in his art.　In this chapter we will examine the other aspects of his painting from the perspective of the critics and historians of Chinese art.

　　侯北人的畫特殊在何處？雖見人見智，但多數人會提到他潑彩的筆法，突出及亮麗的色彩，他的大氣以及他創新的構圖。　本章研討藝術界專家們對侯先生的畫之看法。

Color of Nature　大塊丹青

Yang Shousong, Chinese National First-Class Writer and winner of the prestigious Chinese National Achievement Award, has coined a phase to describe Hau's daring use of color. Loosely translated, he says that Hau's bold and courageous use of color gives Mother Nature a run for her money.

In the preface to the book, *Magnificent and Marvelous Scenes of Hau Bei Ren's Landscape Painting*, Yang asks the question, "Color results from courage, but where does the courage come from?"　He proceeds to answer his own question by saying that it comes from Hau's ancestry as well as his passion and love for his homeland.

Hau's ancestors were from Hebei province, a region known for people with brave hearts and free spirits, who often break into songs of daring that are expressive and rich with emotion.　After moving to Liaoning Province, his ancestors acquired the rugged fortitude of the northerners. When the Second Sino-Japanese War broke out, Hau was forced to leave home alone at the young age of sixteen.　With the country under siege, its land shattered, the young man fled from place to place; the colors of his homeland and his country were imprinted vividly in his memory.　It would later become an element of his art and perhaps even a source for spiritual repose and steadfastness.

楊守松，國家一級作家， 國務院特殊津貼享受者， 稱侯先生為 "色膽包天" 讚他下筆、用色 膽大包天。

在*造化瑰奇侯北人山水畫*之序言中，楊守松問： "(侯北人用色之) 膽從何來？" 隨後他分析認為侯先生燕趙祖先豪放的血源，加上少小離家戰亂流離，對東北家園的掛念是侯北人繪畫用彩的一大激動力。

Not everyone has been able to embrace Hau's color unusual in its boldness and vividness. Some have criticized his color as unnatural and exaggerated.

Feng Qiyong, artist, art historian, noted scholar of the Silk Road and Vice President of Chinese Art Research Institute, has responded to these criticisms.　He has spoken of the verisimilitude of the colors depicted in Hau's paintings.　He has often witnessed them in his travels researching Dunhuang artifacts and the Silk Road history.　He had often wished an artist could one day capture the essence of these glorious vistas and was delighted to see them represented in Hau's paintings.

Chen Peiqiu, a famed and well-respected calligrapher and painter, had high praise for Hau's paintings when she saw them at the Shanghai Exhibit in 2008.　She admired the grand spirit and the brilliance of the color in the paintings and lamented that Shanghai was not the location of Hau Bei Ren Art Museum.

Shu Jianhua, the curator of the Silicon Valley Asian Art Center, has also praised Hau's brilliant color application.　He titled Hau's solo exhibit in July 2009, Color of Nature: The Art of Hau Pei Jen.　In an accompanying seminar to Hau's July exhibit Shu illustrated his point by presenting the audience with the following puzzle containing two images (see fig. 3-1), one from nature and one from a section of a Hau painting. His challenge is to identify which was which.

但有人認為侯先生用的那些強列濃厚的顏色不是大自然的真色。

馮其庸，書畫家，絲路及紅學家，原中國藝術研究院副院長，廷身而出替侯先生做見証。馮先生說他在黃山、皖南、帕米爾高原常見侯先生畫中如武陵幽居圖和皖南山村之景和色。　曾希望有畫家能將這些景色畫出來。如今見到侯先生的畫欣喜無比。

陳佩秋，名書畫家，看了 2008 年侯北人上海畫展後說：“侯先生的畫很有氣魄，了不起，他的顏色很鮮艷，非常新。　像我現在用顏色的量，都畫不到他那樣，這麼好的畫我們上海沒爭取到，　倒是讓你們昆山爭取到了，我真覺得有點遺憾。”

舒建華，硅谷亞州藝術文化中心舘長，敬仰侯先生用彩之神，為侯北人 2009 年七月之個人展命名為大塊丹青。　大塊語出莊子，是天地大自然之意。　丹青是古意也就是彩色。　由此名可見舒建華與楊守松和馮其庸所見略同。為証明侯北人畫的是大自然之色，在畫展之研討會，舒先生問在場觀眾：下面圖 3-1 那張是畫，那張是天然之色？

Fig 3-1

The answer is given in figure 3-2.　圖 3-2 是答案.

Fig. 3-2

A similar challenge was repeated with following illustration.　First, Shu showed the image below in figure 3-3 and asked the audience to point out the painting the image was from.　Members of the audience picked out several different paintings.

隨之舒舘長放映下圖 figure 3-3， 請觀眾指認是那張畫的局部。　觀眾先後指出牆上的兩、三張。

Fig. 3-3

22

Fig. 3-4 Malachite Stone

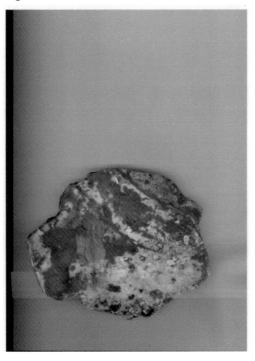

As it turns out, it is an image from a section of a malachite stone (fig. 3-4). When Shu saw the stone in a gem show he attended earlier that year in Tucson, Arizona, he immediately thought of Hau's painting. He purchased the stone, framed it and presented it to Hau and his wife during the seminar.

From these examples above we see that the colors in Hau Pei Jen's paintings are truly related to nature.

但那相片其實是這顆他在阿里桑那州寶石展所收購的綠寶石 (fig. 3-4) 的局部。 他說他一見這顆綠寶石，立時想到侯先生的畫，因之收購並加框贈送侯北人夫婦。

以上說明侯先生畫上的色彩與大自然的相互吻合。 白然與畫是一致的。

Layered Ink to Layered Color 積墨到積彩

While studying at Emperor University in Kyushu, Hau met the famous artist Huang Binghong on a summer trip to Beijing. He began taking lessons from Master Huang. Huang inspired him and taught him about more than painting techniques. Hau recalled what Huang told him: "It is easy to pick up the superficial knowledge of craft, but to learn moral behavior and artistic character will be difficult." Yet Hau persevered, sensing there

侯北人由九州帝大每年暑假回北京，有緣結識黃賓虹先生並認黃先生為師。 侯先生敬佩黃賓虹的為人及藝術。 常說他從黃先生那裡學到的為人處世讓他受益一生。

was much to learn from Master Huang. One person and one sentence has remained a lifetime. Of Huang, Hau says, "[His] art and personal character benefited me my whole life".

Shu Jainhua paid Hau the greatest compliment when he pointed out the following parallels between the two men. In 1954, at age ninety-one, Huang said: "There is not much to my painting; I merely added some unreal things to the real stuff. I have not reached the state I want yet." In July of 2009 when interviewed by Jay Stone, host of the San Francisco Bay Area TV program, Dialogue 360, ninety-three-year old Hau said: "I am not satisfied with my paintings. I am simply continuing to move forward with the exploration."

Shu said: "In the history of Chinese painting, Huang is the recognized expert in ink application. He is without peer in the rich, abundant, and masterful use of ink. When he was young, Hau had the opportunity to learn from Huang. In the sixty years following those lessons, through continuous hard work and daring experiments, he has expanded Huang's layered ink techniques to include the application of color, attaining mastery of layered coloring. Hau's innovation added a modern pulse to Huang's technique of layered ink." In figure 3-5, see Huang and Hau's work side by side. "Hau's superb layered color techniques with their energetic, modern, fresh, and lively feel will undoubtedly leave a glorious page in art history. Hau's most valuable achievement is that he managed to move from layered ink to layered color, while preserving the original method's essential characteristics of vigor, depth, splendor, and moisture."

因之當舒建華在下面幾個例子中指出黃、侯二人類同之處,那是對侯北人最高的讚美。
"我的畫沒有什麼,只不過真東西裏裝點假東西罷了。我還沒有畫好。"
——1954 年 12 月,黃賓虹 91 歲時對黃湧泉的談話
"我對自己的畫一直不滿意,摸索著向前走"。
——2009 年 7 月,侯北人 93 歲接受舊金山灣區八方論談電視節目主持人史東採訪時的談話

舒又說:"在中國繪畫史上,用墨最豐富和最精絕的,首推黃賓虹。侯北人先生青年時代,有機會得到黃賓虹的指授,深受影響。在此後的 60 多年中,侯先生艱苦摸索,大膽創新,在積色法上卓然成家,他的作品色彩之豐富、之精絕,必將在藝術史上留下輝煌的一章。圖 3-5 將黃賓虹和侯北人的畫並列以供參考。黃賓虹的積墨藝術在侯北人這裏得到了符合時代脈搏的創新,被彩色化了,獲得了更現代和鮮活的感受。最難能可貴的是,從積墨到積色,'渾厚華滋'的內在品格沒有變。"

Fig. 3-5 Huang Binghong (left) and Hau Pei Jen (right)

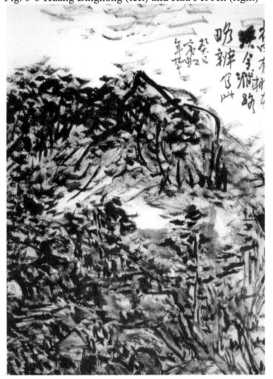 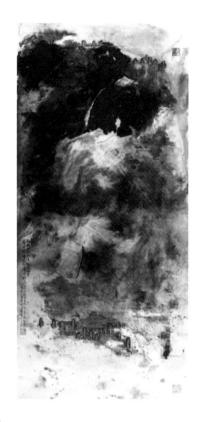

Lyrical and Musical Landscape 山水樂章

Shu Shijun, editor-in-chief of the *Modern Calligraphy and Painting Dictionary,* described viewing a Hau painting to be hearing music of a magnificent and bright landscape. "Hau Pei Jen's landscapes," he says, "have the power of the undulating universe. His colors are fabulous and his spirit is grand." **Shu Jianhua** would not have argued with Shu Shijun on the musical quality of Hau's paintings. When the curator of the Silicon Valley Asian Art Center opened Hau's 2009 exhibit, he showcased these four panels (see fig. 3-6) and declared them musical.

舒士俊，上海書與畫畫刊主持， 首先指出侯北人的畫有音樂的旋律。 他說侯北人的畫是磅礡燦爛的山水樂章。 舒士俊及**舒建華**二舒在這點絕無爭執。 硅谷的舒在介紹侯先生 2009 年的那副四聯屏 (圖 3-6) 也指出那畫的音樂的旋律。

Fig. 3-6

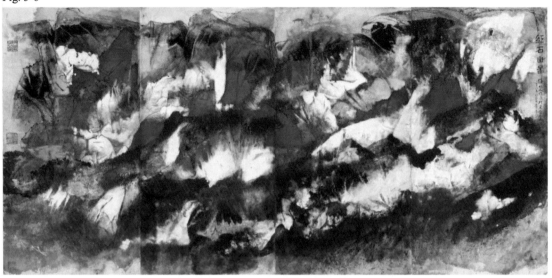

Inspiration and Stimulation　藝術創造的啟發性

Sun Kirk, Beijing Art Institute examiner and editor, described Hau's work as inspirational. Sun said Hau's painting combines modern methods and feel with solid, classical technique resulting in fresh, bold, and free expressions of nature.　His landscapes integrate the form and soul of nature with the spirit of both western and Chinese art.　Even within the current art world his innovation and exploration are inspirational and stimulating.

孫克，北京畫院編審，　談侯北人的畫 "他的畫一方面雖然有很多現代的技巧和感覺，一方面又有非常深厚的傳統功夫，…能够很自由運用傳統表現語言和符號特色。…侯先生對於山水的理解，　對於大自然的形貌能够和傳統繪畫精神山水精神結合非常好…侯先生藝術創造和探索很有啟發性。"

Poet and Artist　詩人畫家

Hsia Suaochi, editor-in-chief at *Art Magazine,* recognized Hau's poetical quality in his painting.　"I've felt he is a poet before he is a painter.　Hau's paintings don't just describe the surface of nature but bring out the soul of nature. They have the core spirit of Chinese painting—the poetry and soul.　He is free and loose in his innovation.　The composition evinces a poetic beauty. Studying a painting of his is like reading a poem.　From an art critic's point of view this is like a breath of fresh air."

夏碩琦，美術雜誌主編，認為："侯北人先生先是詩人而後是畫家。　他的畫沒有對景寫生的實在感，　但他於天地之外別構一种靈氣。　他的畫非常具有詩性靈感的藝術形態。在創作上他是很自由的、放鬆的。　具有詩人的想象力，　他的畫展給我們畫壇吹來–股清風。"

New Direction for Twenty-First Century Chinese Art
21 世記國畫的新方向

Shao Dachien, a professor at the Chinese National Art Institute and Director of Art Theory Committee of the Chinese Art Association, said: "Hau's painting integrates classical and western abstract expressionist techniques; he combines ink and color well and connects the lines and planes excellently. We believe Hau's work signals a new direction for twenty-first century Chinese art."

邵大箴，中央美術學院教授，中國美術家協會 理論委員會主任，在藝術研討會中說："論侯先生的畫確實是中西融合， 不是偏于古典傳统， 也不完全是西方的抽象 表現主義的畫法畫中國畫。 侯北人把水墨和 色彩相結合，把線和塊面相結合做得非常好。…我們從 21 世紀來看我們認為 他是中國畫向前走的一個方向。"

Difference between Hau Pei Jen and Zhang Daqian 潑彩不同於張大千

Wong Zhitsung, Special Assistant to the Executive Director of the Beijing Art Institute, compared Hau's painting with Zhang Daqian: "Hau's paintings are solid, grand, and have a modern feel. His splash color has gone beyond that of Zhang Daqian. Zhang's splashed ink used mainly traditional green and blue color. … Hau has employed a wider choice of color, including heavy use of white pigment producing refreshing effects…. Hau's created forms and vistas are based on the results of the poured color. He cuts and pastes elements of nature combining them using western abstraction techniques in composition and color control to mold the image into a painting of nature."

王志純, 北京畫院院長助理, 有下列的看法。"侯先生的畫厚重, 大氣, 有一種非常強列的現代感。我覺得潑彩如果和張大千比拓寬很多。…張大千主要是潑墨，基本上限於中國畫青、綠顏色。侯先生色域寬並大量用白， 畫面形成非常新的效果。….他基本上是一種造景，抽象的元素很多，由拼接效果西方結構意識來駕馭潑彩。"

Chapter Four: The Art of Hau Pei Jen–Students' Perspective
第四章 侯北人的畫，另一觀點

In the previous chapter, we presented observations and comments from the professionals on Hau Pei Jen's art. In the current chapter we will discuss the principles of art Hau Pei Jen has advocated as an art educator and teacher. For over fifty years, he has taught Chinese brush painting at the Pacific Art League in Palo Alto, California. Through Hau, hundreds of students have advanced their knowledge of Chinese art and learned to enjoy it in practice, as well as in theory. His corps of students is international in character, and it includes Chinese- and non-Chinese-speaking artists alike. He teaches through actions more than words. Given his legacy as an educator, exploring his students' perspective offers additional insight into Hau's art.

Hau's paintings are a compelling fusion of the old and the new. This chapter is therefore organized to reflect this parallel development of old and new. Further, we will probe the factors that contributed to his innovation and finish by naming the principles that unite his paintings.

The material for this chapter came from three sources: Mr. Hau's teachings, discussions of Hau's students and analysis by the author.

第三章收集了專家們對侯先生畫之評語，本章緊接着以侯先生弟子的眼光來研討他的畫和他的教學方法。以侯先生學生的眼光來看他的畫及他的教學方針是了解他畫的重要一環，因為侯北人不僅是一位成功的藝術家更是一位有成就的教育家。他在美國加州柏拉奧圖的太平洋藝術聯盟授課，長達五十餘年。受他薰陶啟發的學生無數。他的學生來自世界各國，有許多不會中文。侯先生以身示教，啟發他們。因之從學生及課堂上應對的觀點來看侯先生的畫會見到與專家們不同的內涵並加深對侯先生畫更多一層的了解。

侯先生的畫承先啟後。本章將先從傳統着眼，再看他創新之處，並探討他入畫的統一原理。

本章資料來自三處：侯先生課堂片面，同學之間的研討及作者自己課外的分析。

Traditional Chinese Painting Characteristics 傳統中國畫要素

While Hau is demonstrating during class, he frequently points out to his students the elements of a good Chinese painting. These are times when the lesson expands and verges on magical. The students are no longer learning just a specific technique; they have been made privy to the thought processes and the driving principles behind his approach and the choices he makes in its execution. One common criticism of Chinese painting as well as its teaching methodology is the overreliance on rote

侯老師鼓勵他的學生要畫自己的畫，不要只抄襲他。因此常在課堂講解中國好畫千年不變的原理。當他講原理時，我們的課也神奇的擴展開來。不僅由此學到技巧，又學到思考創新的能力。他的教學方式和他的哲理是一致的。他不僅提供學生們好畫來模寫，更解說作畫的邏輯和過程，讓我們有機會建立思考，有評斷取捨的能力，侯老師讓我們有勇氣去探新摸索。我們從觀察模仿侯老師及先賢的好畫打基礎，

copying. Hau encourages his students to learn from him but not simply to copy him. His teaching method is consistent with this philosophy. He not only provides students with good painting examples to model from, he also explains the logic and process behind his approach so students can build judgment, explore technique, and develop their own styles. As human beings we develop many extremely complex abilities—social, linguistic, and kinesthetic—first through observation and mimicry. After establishing a firm foundation in this manner, the student becomes free to improvise. It is in this context, then, modeling after the masters makes sense. The framework that Hau builds with his students is, in fact, freeing.

The core Chinese painting elements frequently discussed in Hau's classes are resonance of spirit; simplicity; manifestation of character; harmony; subtlety and depth; and poetry and calligraphy As a first step in understanding Hau's teachings, these elements, readily observable in his paintings, will be expanded upon here.

再由侯老師啟發扶導去尋找自己的路子。他的教學方針讓我們不受局限，而且有發展的空間。

下面章節將討論一些他時常在課堂上提到，同時也是他畫中常見的傳統中國好畫的因素。這些因素包括神似和氣、意高筆簡、筆墨性情、合諧、含蓄藏露、詩字和畫。

Resonance of Spirit

Regardless of the subject matter, Chinese paintings traditionally strive more for resonance of the spirit than for realism. The artists strive to see the subject from its surface through to its spiritual core, and then to express the essence of the subject in their paintings. Historical teachings of this principle are widely evident. A Yuan Dynasty poet and painter, Ni Tzan (1301–1374), once said of Chinese painting that it was "just a few handsome strokes" and was "not looking for object resemblance." Modern master Huang Binghong (1865–1955) went one step further. He encouraged the concept of combining both abstract and realistic approaches in the same painting saying "the unreal and the real together create a truer image." The great modern Chinese artist Qi Baishi (1864–1957) advocated resonance of the spirit as well saying, "Excellence in art lies between the

神似和氣

中國畫講究神似和氣。早於十四世記，倪瓚提及"逸筆草草不求形似"。近代大師黃賓虹也說畫要虛實有加，抽象與具象相配和。齊白石大師也說畫妙在似與不似之間。畫有神似之後會產生自身之氣。侯先生的畫氣勢壯觀活躍。圖 4-1 *山韵* 為一例。說它是山好像又差了些具象的細節，說它不似山，神氣又強過真山。山脈之神律、肌理、及氣勢全活現於觀賞者之前。

likeness and the unlikeness." By combining abstract and realistic approaches, and choosing resonance of the spirit over realism is what sometimes differentiates the Chinese artistic perspective from the western. As importantly, an orientation towards resonance of the spirit allows good paintings to create their own rhythm and expression, and thereby form their own spirit or chi. Hau's paintings possess chi that is grand, vibrant and expansive.

The painting *Mountain Rhythm* (fig. 4-1) is a fine example of resonance of the spirit. The spirit, texture and the power of the mountain is alive for the viewer.

Fig. 4-1 *Mountain Rhythm,* 18"x21", 2008

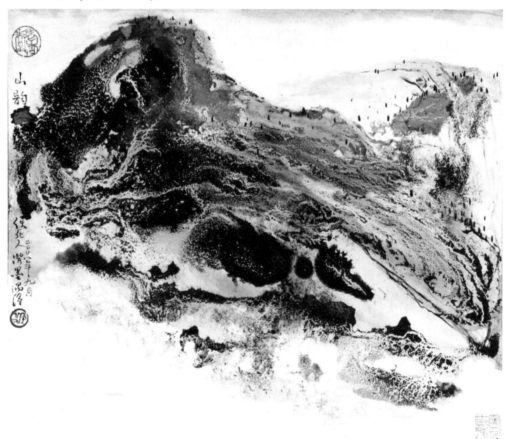

Simplicity

Hau reminds students often that "less is more. Simplifying the clutter and capturing the essence produces more impact from your images." Students are periodically reminded that including unnecessary elements in a painting is like drawing feet on a snake.

The painting, *Mi Mountain* (fig. 4-2), succeeds in saying more with less leaving room for viewer's imagination.

意高筆簡

侯老師常提醒學生：「意高則筆簡」。又教我們不畫蛇添足。

圖 4-2 *米家山* 為一意高筆簡之例。潑墨潑彩加上一些疏疏落落的米點，點出山韵空靈給了觀賞者許多想像的空間。

Fig. 4-2 *Mi Mountain,* 18"x21", 2008

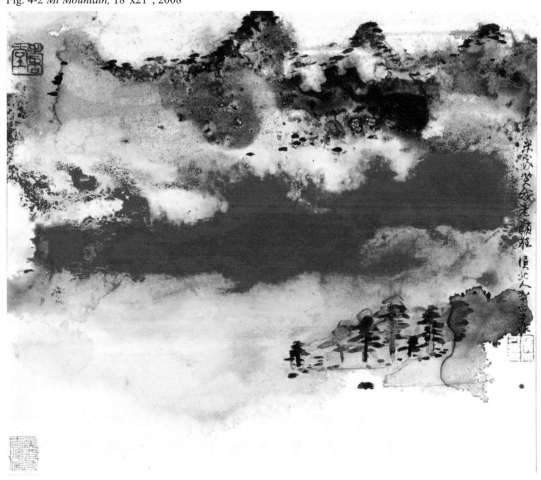

Fig. 4-3 *Zen Temple Path,* 54"x27", 2008

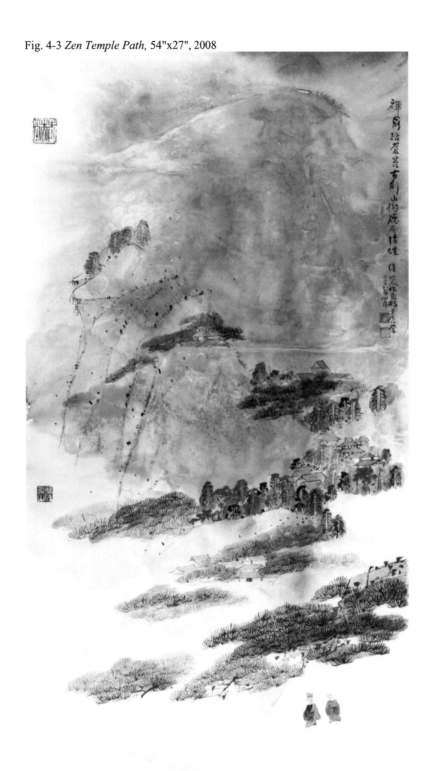

Manifestation of Character

The Chinese, as a people, seldom exhibit strong emotional outbursts. Instead, sentimental, powerful, and profound feelings are expressed through literary works and paintings. Historical texts from as early as the Six Dynasties (221–581) have been found which show that many painters had begun producing work not as a strict representation of the subject but rather as a manifestation of their own character and temperament. Expression was added to the emotionless objects by imprinting the painter's personality and feeling, reflecting not only visible reality but also a personal view and emotional response to the surrounding world. Kuo Johsu (ca.1070) wrote in *T'u-hua Chien-wen Chih* that paintings are the seal imprint of the heart.

Hau is a living example of these concepts. He is what Emperor Xiao Yi-Liang Yuan Di (508–554) described as a man of "high virtue with excellence in brush and ink work." His actions and his art are an embodiment of the idea that a beautiful heart brings forth beautiful paintings. Confucius espoused five basic virtues of a gentleman: gentleness, kindness, respectfulness, thrift, and humility. These five characteristics are evidenced by Hau and his paintings. *Zen Temple Path* (fig. 4-3) is a painting which speaks to Hau's inner virtue.

筆墨性情

中國人一般情緒內歛. 感傷、言情付之於書畫。

史書記載早在六朝(221 – 581)時，畫家已具筆墨性情之風。

郭若虛 (ca.1070) 作《*圖畫見聞志*》以畫及印做對比，說畫是心靈之(章)印。也為筆墨性情加定義。

侯老師鼓勵學生要修身養性、多讀書有內函才能畫好畫。一位精通儒、佛、道學專家同時也是尊仰侯北人畫藝多年的學者指出侯老師俱有孔夫子所言的温、良、恭、儉、讓的君子風度。他的畫，圖 4-3，*禪罷踏青苔* 具備梁元帝蕭繹 (508-554) 所言之"格高逸筆墨精妙"。

Harmony

Harmony is an important element in Chinese painting. Harmony does not mean monotony or lack of opposing energies. A good painting contains many opposite forces such as yin and yang, black and white, fast and slow, lightness and heaviness, density and sparseness, fullness and emptiness, stillness and motion, big and small, solid and broken, light and dark, cold and warm. Hau teaches students to utilize varied and opposing forces but also to work at keeping their coexistence beautiful, lively and balanced.

Careful examination of Hau's painting reveals contrasting yet harmonious elements at work. However, given that color is a prominent element in Hau's paintings, when focusing on harmony, color must be considered. Take a look again at the painting *Small House in Misty Rain* (fig. 2-7) discussed in chapter 2 earlier. This painting challenges the traditional concept of harmony if one excludes the color. By adding the strong, eye-attracting red spot in the painting, does it not counterbalance the large black mass and allow the painting to achieve overall harmony?

和諧

侯老師認為畫要有對比及合諧才能生動耐看。他注重應用多元相對的元素，譬如陰陽、黑白、快慢、光暗、緊鬆、實虛、靜動、大小、冷暖等，以達成共存生動又平衡之美。

色彩是侯老師畫面的基本要素。考慮平衡合諧必得將色彩加入等衡公式中。Figure 2-7曾對古典合諧概念挑戰，但若加色彩於等衡公式之中再次考慮合諧，那搶眼的大紅點不也帶進了平衡嗎？

Subtlety and Depth

Good Chinese paintings are seldom "in your face." Beauty is achieved with delicacy. Often more is expressed by the elements that were omitted or obscured than by those that were shown. The famous poet Bai Juyi (772–846) once wrote a poem describing the entry of a singer: "After much pleading and beckoning, the singer appeared at long last, but with a musical instrument covering half of her face." One can sense the anticipation through the poem and imagine the beauty of the singer even though—or perhaps because—her face is half-covered. Once while reviewing a student's landscape, Hau used a waterfall as an example that showing an uninterrupted frontal view is not necessary. More interest might be generated if part of the waterfall were to be obscured by trees. A partially covered waterfall has a subtle beauty and like the singer's half-covered face is a more inviting, seductive element. Deciding what to show in a painting and what to obscure or omit is a key component of the composition.

Subtlety doesn't mean omitting all details. Hau points out that Huang Binghong's paintings are examples of the technique of creating layer upon layer of details subtly embedded in the painting for the viewer to discover. Hau's paintings are not unlike that of Huang's. The more they are examined, the more layers they reveal. Observe the painting, *Cai-Shi Mountain* (fig. 4-4), and discover the anguish, the lament, and the passion embodied in the painting as vividly as it is depicted in the eponymous Song dynasty poem, Cai-Shi Mountain E-Mei Pavilion.

Cai-Shi Mountain E-Mei Pavilion

Cai-Shi cliff inserts itself high into the sky,
Drops straight down a thousand feet toward the river below.
Far away, East and West Liang Mountains, two knotted eye-brows,
Express endless worry and lament.

含蓄藏露

侯老師替我們講解黃賓虹畫藝時，指出黃之積墨深刻含蓄之妙。經過這堂課後我們再看侯老師的畫也見它含蓄深刻耐看。具有白居易的 "千呼万喚始出來，猶抱琵琶半遮面" 的含蓄風格。有一次在課堂上侯老師以一位學生畫的瀑布為例，指出正面全片的瀑布水流不如半遮半掩的有趣味。在樹林後半隱半現的瀑布不正也像琵琶半遮面的歌手一樣更吸引人嗎？決定一幅畫中那些東西要露、那些要藏、那些要完全取消是構圖的一大要點。

含蓄並不表示沒有細節。例如，侯老師教我們看黃賓虹之畫，看黃大師一層層累積着把細節往上加，讓看畫的人越看越想去發現細節。我們看侯老師的畫也是如比。細看圖4-4 *采石磯*，一層層的愁情怨意深藏在山中，媲美宋韓元吉之詞采石磯娥眉亭。

采石磯娥眉亭

倚天絕壁。直下江千尺。

天際兩蛾凝黛，愁與恨、幾時極。

怒潮風正急。酒闌聞塞笛。

試問謫仙何處，青山外、遠煙碧。

The evening tides aided by the wind
thrust up angrily;
Sober ears hear army bugles
And wonder where the beloved poet
Li Bai (李白) is:
Far away, beyond the green
mountain in the smoky mist.

(Cai-Shi Mountain is the
resting place of the poet Li
Bai.)

Fig. 4-4 Cai-shi Mountain, 84"x37", 2008

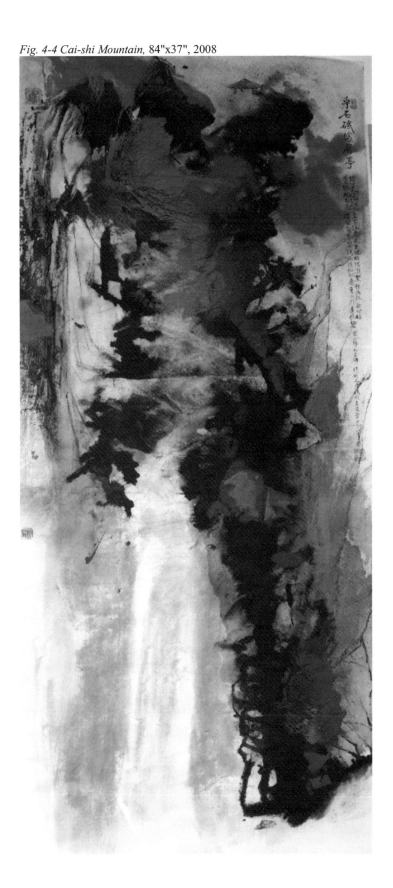

Poetry and Calligraphy

Historically, artists often were or claimed to be members of a socially elite class of educated men who practiced multiple types of art including painting, poetry, calligraphy, and sometimes even music. This gave rise to the long tradition in China of the literati as artists. Indeed, it is hard to disentangle one of these art forms from another. Calligraphy has close ties to Chinese painting as its brush techniques provide the foundation to the Chinese brush painting skill set. Classic poems and literary works often offer inspiration for master paintings. Additionally, Chinese artists often include calligraphy and poems in their paintings, making them an integral part of the composition. This further consolidates the link between these art forms. The Greek poet Simonides (ca. 556 B.C.–468 B.C.) said, "Poetry is vocal painting, as painting is silent poetry." After seeing the painting, *Misty Rain of Languan,* by the Tang artist Wang Wei (701–761), the Song Dynasty poet Su Dongpo (1037–1101) said that one could visualize painting in Wang's poetry and hear poetry in his painting.

Evidently, in the western and eastern worlds alike, poetry and painting are intertwined artistic expressions. Throughout his childhood Hau studied calligraphy and poetry from his grandfather, an Imperial Scholar. Multiple art forms are second nature to him and strengthen his painting. The host of the Dialogue 360 television show, Jay Stone, introduced Hau as having the "eyes of a painter [and the] heart of a poet." Hau's students certainly agree, especially when Hau discusses the poems that led to the paintings whether his own work or that of the ancient masters. In his painting *Cloudy Mountain* (fig. 4-5), Hau inscribed this poem that he had composed.

Cloudy Mountain

Clouds stopped moving on the mountain top
Rain misted at the mountain foot,

詩和字

詩、字與畫常為一體。古希臘詩人賽蒙尼德斯說"畫為無聲詩,詩是能言畫"。蘇東坡看過*籃關烟雨圖*稱讚畫家王維 "詩中有畫、畫中有詩"。可見中外皆有詩畫一體的同見。侯老師詩作得好、字寫得好、畫更精妙。詩詞生意和題註是侯老師畫好的一大因素。

舊金山灣區電視八方論談節目主持史東介紹侯老師為:"畫家的眼,詩人的心"。我們同學們也常有同感,尤其是侯老師在課堂上為我們講解那些題詩或因詩而做之畫時,這個感觸就更深一層刻印我們惱海。

Figure 4-5 *雲山圖* 中題有侯老師的詩。 記錄在下。

雲山圖

山上停雲山下細雨
深鎖着古剎峯巒
蒼蒼茫茫

Deeply binding old temples and mountain
range
In boundless misty gray.

The poem and the painting interact. The
resulting image is a charged and emotion-
filled place, more powerful than the real site it
depicted.

讀了這首詩再看這幅畫，會感覺到詩及畫的相
互呼應而進入比實境更高一層的境界。有想像
的成分，也感應到畫家作畫的心情，更有飛躍
交錯幻化的感覺。

Fig. 4-5 Cloudy Mountain, 84"x37", 2008

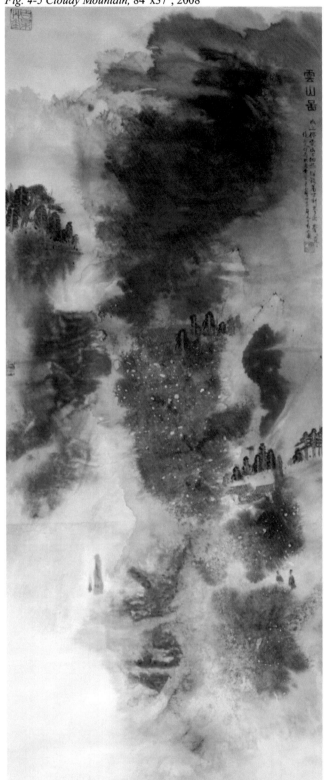

Innovations in Hau's Work 創新之處:

Hau's paintings contain many worthy innovations: in his response to his times, in his splash color from the heart, in his incorporation of abstract and expressive elements, and in his nontraditional compositions. Before we delve into a discussion of these, I would like to explore the factors that motivated him to change.

What drives an artist to innovate? For Hau the seeds of change germinated on two fronts. One was internally sourced and the other had an external stimulus.

Ming dynasty artist, Shi Tao (1630–1724) advised artists to reflect their time and place and to develop their own style. His own work vividly demonstrated his personality and reflected the times in which he lived.

Hau respects Shi Tao as an artist and no doubt is influenced by Shi's thinking. Additionally, Hau's teacher Huang Binghong also encouraged his students to innovate. Shi's and Huang's teachings alone would be inspiration enough for Hau to seek new ways of artistic expression. Hau believes strongly that each artist has an obligation to show what they see and feel in his or her art. The world in which we live is different from that of even twenty years ago before the dawn of the Internet era. It is a livelier, freer, and more internationally intertwined world. Hence new art forms are needed.

除了保有傳統的中國畫的要素之外，侯老師之畫也有許多值得一談的創新之處。本節將取四項討論：反應時代的畫、隨心潑彩、抽象寫意又寫情、及非傳统式構圖。但在討論他創新之前，我們先探討他創變之因。

石濤注重創新，提出："借古以開今"，"師法自然"，及 "我用我法"，又言"搜盡奇峰打草稿"等創新法。黃賓虹也鼓勵他的學生創新。侯老師尊敬石、黃二位大師。創新起源於二位大師。除了二位大師的影響，侯老師課堂常提及另外促使他創新的因素。如反應時代及國際畫壇的衝激，討論於下。

Response to the Artist's Times 反應時代的畫

Hau has said that he believes artists are privileged individuals. They are privileged because they are given the ability to see and feel as well as the talent to express what they see and feel in their work. They have "godlike" power when painting. In their paintings they can bring about rain or shine as they wish. If

侯先生認為畫家有獨特的眼光和感覺，作畫時又有呼風喚雨和移山倒海的技能，但也相對的有任務畫出反應時代的畫。這內心的看法加上外界環境的刺激給了他不停創新的動力。

the artist feels a mountain peak is lacking he/she can add one and where rocks are random and obtrusive, he/she can remove them. Artists can imagine a dreamland in their minds' eye. A landscape artist with a few brush strokes can remove mountains or reverse the ocean's flow. Artists can create another world to pick up where Mother Nature left off. Such power is not unchecked. An artist's ability to edit his own ideas is a crucial skill.

Hau believes that with this power and privilege there comes also a responsibility. Artists need to reflect in their painting their times and their world, albeit following their own inspiration in deciding how to paint and what to represent. This conviction urged him to break away from traditional methods. It provided fertile ground for external stimulation.

Splash Color from the Heart 隨心潑彩

The other seed of change came from his friend and famed artist Zhang Daqian (1899–1983). During the 1960s and 1970s, Zhang Daqian and Hau Pei Jen both lived in the greater San Francisco Bay Area. They often met to exchange ideas. Zhang exhibited with Picasso in Paris in the late 1950s. Seeing that Chinese ink paintings with excellent technique and perfect execution paled alongside the colorful works of Picasso, Zhang recognized a need for reviving color in Chinese paintings. As we have seen, color is not a new element for Chinese painting. Heavy colors were used in Tang paintings as evidenced in Dunhuang frescoes. But due to the unavailability of source material, color lost favor to ink in subsequent times.

Zhang's comments as well as the influence of living in the colorful, dynamic twentieth-century America were two catalytic, external forces for Hau. These forces were engaged by a fertile, receptive mind. Together, they propelled Hau's entry into the world of bold, vibrant, and saturated colors. Colors—such as bright red, green, gold, and whites avoided by

1960 和 1970 年度張大千和侯北人同時居住在加州灣區。二人時常聚會，研討畫藝。張大千和畢加索在巴黎同展回來，曾感嘆告知侯北人若想在國際藝術界佔一席，中國畫需將色彩重新引進其中。

張的話及二十世紀美國的多彩的物理環境給了侯北人用彩創新的動力。多年研討，創出隨心潑彩的方法。圖 4-6 *江行* 是一例。

Chinese artists before him—are used liberally by Hau. He splashes color from the heart with courage and freedom as exemplified in his painting, *River Journey,* figure 4-6.

Fig. 4-6 *River Journey,* 36"x72", 2008

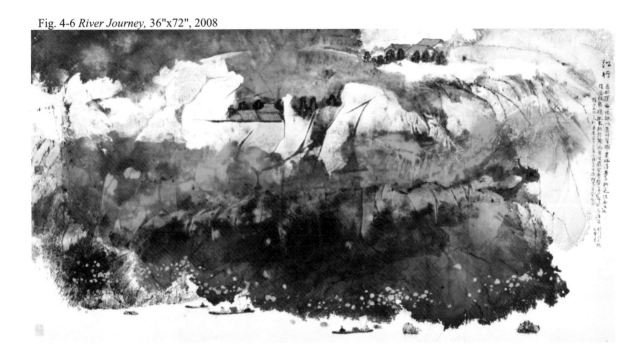

Incorporating Abstraction and Expressiveness 抽象寫意又寫情

When asked who among the Western artists he appreciated the most, Hau named Van Gogh and Cezanne, both postimpressionists. He admired their passion and courage to paint how they felt and what moved them in their hearts. Whether it was the influence of Van Gogh and Cezanne painting from the heart or the influence of Huang Binghong's mixing of abstraction and realism, over the years Hau incorporated more and more abstract and expressive elements in his painting.

By Hau's own admission, he strives to paint the spirit rather than the object. He is not interested in producing a photographic likeness of a scene. Rather, he intends to show the beauty of the landscape as he sees it and to recreate the feeling it stirs in his heart. He would say the secret lies in finding the right balance between the "like" and "unlike" so that the resulting image transcends a exact reproduction of the natural subject. When the heart and soul are channeled, intentions will form before one starts to paint and will serve as a guide to the brush. Figure 4-7 *Changbai Mountain Sunset* is an example of a subject that he painted from his heart, remembering the awe he felt as a child when he first saw this scene with his mother. He expresses not just the beauty of the land but the longing in his heart for his mother and the motherland.

有次侯老師被問到西方畫家他最欣賞誰。他說梵高和塞尚。他敬佩他們二位的畫藝，更崇敬他們熱誠認真的精神，真誠的畫出他們心中的畫。

侯老師曾自書寫意不寫實。也許是黃賓虹先生的影響，也許是梵高和塞尚的呼喚，近年來侯老師的畫更加多抽象及印象的畫風，也更顯出他對家園山水的依戀及他內心的情懷。

Figure 4-7 *長白山夕霞*不僅畫出山水之美也畫出了侯老師一生的情感和他對親情及家鄉的懷念。

Fig. 4-7 *Changbai Mountain Sunset,* 36"x72", 2009

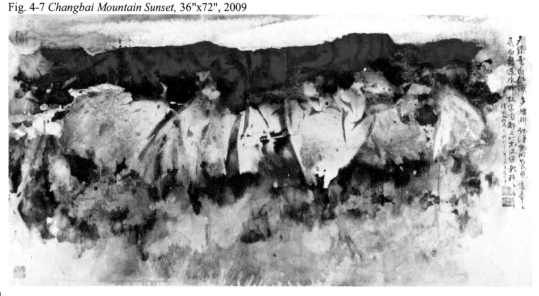

A detail of the painting showing the inscription can be seen in figure 4-8.
圖 4-8 為*長白山夕霞*細節。侯老師題詞也記錄如下。

Fig. 4-8 *Changbai Mountain Sunset, detail*

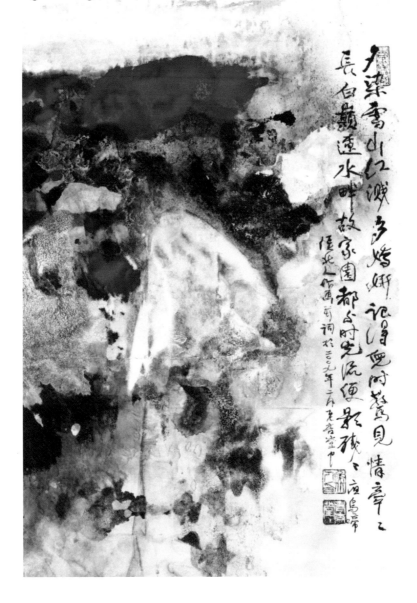

Hau composed the poem inscribed in the painting which is translated below:

Evening clouds dye the snowy mountain red, how beautiful
The surprise, first seen in childhood, that tugs at my memory.

夕染雪山紅濺多嬌妍
兒時驚見情牽牽
長白巔遼水畔舊家園
都與時光流便影殘殘

烏夜啼詞

Changbai peak, Liao riverbank, old home and
 garden
Disappear with time; shadowy, the images are
 fading.

When one paints from the heart, artistic license may be exercised to change the order or existence of subjects. Hau insists that natural laws and aesthetic principles not be violated in making choices and that the artist strive for resonance of spirit and for harmony with the universal forces at work. This is the philosophy that allows him to create paintings that are both rich in traditional beauty and exciting in modern energy.

從心而畫，畫家的畫需要在自然景物中添加或刪減。侯老師說此時一定要做到"合美、合情、合理"。這是他的畫麗而不俗的原因也是我們這些學生需要學習之處。

Nontraditional Composition 非傳統式構圖

Changbai Mountain Sunset (fig. 4-7) also illustrates how he adapts the western compositional technique of utilizing the entire canvas in a Chinese landscape.

Using the full canvas is not his only innovation in this composition.　As Professor Kao describes in chapter 2, one can see in several of Hau's paintings that he challenges the compositional traditions of perspective and balance.

To innovate compositionally is not easy. Hau encourages his students not only to study ten-thousand books and walk ten-thousand miles but also to think and observe constantly. The "books" and "miles" give artists a foundation and empower them to observe and understand what they have seen.　To think is to synthesize and distill the senses into an abstract core.

When Hau paints, he is fond of saying that he "listens to the fragrance of the sites and scenes" in his imagination.　Study, travel, reflection, observation and the mantra of "listen to the fragrance of the sites and scenes" taken all together provide perhaps some insight into Hau's source of innovation.

侯老師在構圖上有許多創新之處。*長白山夕霞* (fig. 4-7) 為其中之一。它是依西方構圖之例運用全部畫面作畫。

其他侯老師非傳統式構圖的例子在本書第二章曾經討論過，在此不重復。

侯老師常提醒他的學生們構圖創新不容易。他鼓勵我們要讀萬卷書，行萬里路，更要常思考觀察。　多讀書、多行、多看、多長見識 會讓畫家有基礎，有能力了解所見之情或景，更因此而能刪除、取、捨以求神似之核心。

一位侯老師多年的學生說她最牢記在心的是：侯老師說他作畫時總提醒自己別忘了當初見到那作畫之景點時所有的感覺，包括視、聽、嗅、觸和心中之情感。多讀書、多行、多看、多長見聞再加上作畫時不忘記取當初見景時所有的感覺也許是侯先生構圖創新以及取神似核心之一祕訣。

Analysis of Hau's Work Using Elements of Art
水墨丹青侯北人

In this section analysis will be conducted of Hau Pei Jen's work using Visual Thinking Strategy.

本章節我們以視覺思考策略來分折侯老師的畫作。

The Method
Visual Thinking Strategy (VTS) is an educational methodology for teaching critical thinking, analytical reasoning and problem solving skills.　(Please refer to appendix II for details on VTS.)　In this section, I will use VTS processes and the five elements of art—dots, lines, shapes, color, and texture—as a tool set to attempt to answer the question, "What is new and different about Hau's art?"

分折方法
視覺思考策略 (VTS) 是一個有效的關鍵思考、分析推理及解決問題的教學方法。(VTS 細節請參考附錄 II。)筆者曾對下列問題長思 "侯北人先生的畫新在何處，不同在那？"　因之決定以 VTS 方法及點、線、形、色及肌理等五藝術元素為工具來探索、分析並將結論在本節提出討論。

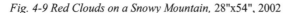

Fig. 4-9 Red Clouds on a Snowy Mountain, 28"x54", 2002

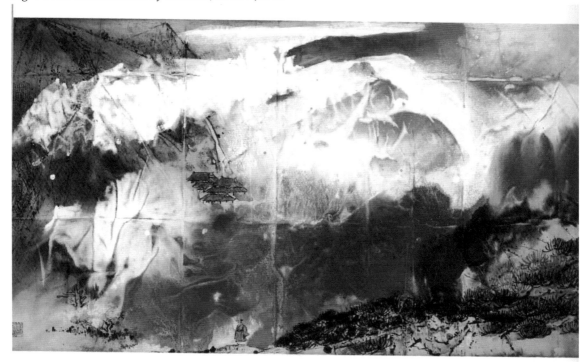

Before discussing the results of the VTS exercise, first a few words on why dots were added to the four more commonly recognized elements of art: lines, shapes, color, and texture.　Dots occupy very little space but play a prominent role in Chinese paintings.　Hau teaches that while the dots' appearance in a

在討論 VTS 分析結果之前，先說明為何將點加入尋常所說之線、形、色、及肌理四藝術元素中而成為藝術五元素。'點'是中國畫極重要的一環。點在一幅畫中初看不起眼，像散亂、隨意而置，但精心而營的點會顯出畫的核心，有畫龍點睛之妙。因之在線、形

48

painting may seem random at first glance, randomness is the furthest from the truth. Everything about dots starting from their size, shape, placement, manner of application, and variation of ink strength, are all carefully considered and rendered in order to give the painting its proper effect and focus. The dot added as the eye of the dragon is what brings the dragon alive. The most common mistake in a student's work is the missing eye.

Using VTS, I look first for the five elements: dots, lines, shapes, color, and texture in Hau's paintings. Then I watch how Hau presents these elements and pay attention to the way he combines or separates these elements in each painting to create the desired effect. This exercise allowed me to discover some special characteristics of Hau Pei Jen's art. I will discuss my conclusions using figure 4-9 *Red Clouds on a Snowy Mountain* as an example.

、色及肌理外必需加多一項'點'而成藝術五元素。

我以 VTS 程序和點、線、形、色及肌理這五元素為工具觀察、分析多幅侯先生的畫，重復問自已侯先生如何分類組合這些元素來傳神。慢慢的也看出一些心得結論。以 figure 4-9 *雪山丹霞*畫為例而論之。

Conclusions 心得結論

Ink and color are integrated in Hau's painting. He treats water, ink, and white pigments as a continuous spectrum in color. Clear (the original color of the paper), pigments of white, black (ink), and the many shades of gray in between are used to create the moods of the paintings.

Colors are used to create forms. Shapes and colors are intimately linked. Often, color is applied by pouring. As the color flows into and across the page, an abstract, organic, dynamic form results.

Dots and lines are applied in ink. They are used to outline shapes and create texture. Textures are created by expert ink strokes in the form of dots and lines. Taking *Red Clouds on a Snowy Mountain* as an example, imagine the upper left without the texturing lines and dots; it would flatten the image and lose the connection to a snowy mountain. More often than not, the creation of texture is a stumbling block for students who have not yet acquired the level

水墨丹青是融合一體的
侯老師的畫是水墨和丹青融合一體的。　水 (無色，留白)，白色顏料，墨黑及其他之顏色，都是彩。水、顏料、和墨合一製造畫之神情。

以色起形
形與彩是親密的連貫著。彩多為潑上。當彩隨紙動而流，抽象的形及韵律隨之出現。

水、墨、點及線成肌理
肌理之精華在點及線。以 figure 4-9 *雪山丹霞圖*為例，若左上部位沒了那些肌理的點及線，畫面缺少立體感不說，雪山連想也消失。水墨點線成為肌理是我們學畫者一大難題。侯先生具有深厚的筆法墨法。他能將*黃賓虹畫語錄* 所言之平、圓、留、重、變 五筆法及濃、淡、破、潑、漬、焦、宿之七墨法運用自如，枯而能潤，剛柔互

of brushwork and ink skills necessary to carry out their intent. Hau has the five brushwork skills—balance and control, smoothness and flexibility, subtle connectedness, power and vigor, and lively variety—and seven ink control skills— dense ink, light ink, broken ink, splashed ink, layered ink, scorched ink, and aged ink—that Huang Binghong describes in *Collection of Art Theory*. His brush strokes are dry, yet have moisture; the harshness and softness are mutually supportive. These skills allow him to capture spiritual resonance and elevate his painting to the realm of "balanced extremes" as described by Huang Binghong: "Dryer than the bitter wind of autumn yet containing moisture as soft as spring rain."

Hau builds shapes based on the flow dynamics in the colored form. According to the dynamics of the color flow, Hau uses ink to create texture and highlights, and, in turn, to solidify the abstract form. The ability to interpret, abstract, and capture the spirit of a splashed ink-and-color image takes years of practice and study. This aspect is perhaps the hardest for students to learn and some may never master it. Because it is highly subjective and interpretive, this is an area where elusive "inner virtues" can determine an artist's effectiveness.

The whole is more than the sum of the parts. Brilliant colors in Hau's paintings sometimes make it difficult for a viewer to focus on other aspects of his art, some of which I have mentioned above. Hau's genius lies in the intersection between superior ink and brushwork techniques and the unique use of color, between the "autumn wind" and "spring rain," and between rigorous practice and the subjective inner world.

濟，有質有韵，達到黃賓虹所言之乾裂秋風，潤合春雨之境界。

因勢造形.
以彩起形，因勢造形。似是而不是，不似又極似，是一妙也。這也是學侯先生畫最難之處。 沒有侯先生之學素修養及多年苦練，難以由潑彩中取山水之神，更難因勢造形。

總結.
亮麗强壯的色彩常讓人錯過侯老師畫中其他過人之處。
但經由上述 VTS 觀畫之程序，我認為侯先生畫不僅為水墨丹青創新，又達到黃賓虹所言之乾裂秋風，潤合春雨之境界，潑彩山水不止記形更傳神。

50

Comparing Hau's Guiding Principles to Traditional Principles
基本法則

Whether painting with traditional techniques or experimenting with new approaches, Hau followed a few tried-and-true principles. These principles listed below were first described in the Song Dynasty by Xie He and are commonly known as Xie He's Six Methods

不論是用古法或創新，侯老師還是尊重六朝謝赫六法的。

氣韻生動 – Include the necessary elements of a good painting, i.e. liveliness, rhythm and spirit.
骨法用筆 – Work the brush in a controlled manner in the way derived from the art of calligraphy.
應物象形 – Form the shape of your subjects according to reality.
隨類賦彩 – Apply color according to the natural world.
經營位置 – Arrange the composition.
傳移模寫 – Learn from the old masters and use your imagination to modify the scene.

As Hau developed his style, he added one more.　為潑彩他多加一法。

因勢造形 – Build the form and shape of the object according to the dynamic rhythm of the color flow.

Thus, after necessary adjustments, Hau's six principles became:　侯先生的六法是：
意在筆先 – Know the painting concept in your mind before you start.
氣韻生動 – Include the necessary elements of a good painting, i.e. liveliness, rhythm and spirit.
隨心潑彩 – Splash color from the heart with courage and freedom.
因勢造形 – Build the form and shape of the object according to the dynamic rhythm of the color flow.
骨法用筆 – Work the brush in a controlled manner in a way derived from the art of calligraphy.
小心收拾 – Finish the painting minding the details with care.

Comparatively speaking, Xie and Hau follow many of the same principles.　The main difference in the methods of Xie He and Hau is in their treatment of reality versus rhythm and imagination. Xie's method is bound by the rules of calligraphy and reality as in 骨法用筆 and 應物象形. Hau starts with splash color from the heart (隨心潑彩) followed by building form and shape according to the flow of the color and ink (因勢造形).　Water, ink, and color add a dynamic, organic rhythm to the image and allow the artist a degree of freedom in constructing the image. More creativity and expression can result from this approach.

比較而言，謝氏六法與侯北人六法有許多相同之處。最大的差別處是謝氏主張骨法用筆和應物象形。此二原則令畫家受制於現實形象。侯北人偏重隨心潑彩和因勢造形。水墨及顏彩潑動自有它的韻律及能量，給了畫家多些空間去創造形象因而多些發展、表達的自由.

Part II

Chapter Five: Splash Ink and Color, Step-by-Step
第五章 潑彩逐步示範

In this chapter notes from Hau's classes as well as from the 2009 Asilomar Workshop will be used to illustrate how, step by step, a splash ink-and-color masterpiece, *Morning Clouds at a Mountain Estate,* figure 5-1, is created.

本章將以 figure 5-1 *山莊朝霞*為例分段解說侯先生潑彩過程。

Fig. 5-1 *Morning Clouds at a Mountain Estate,* 25" x 38", 2009

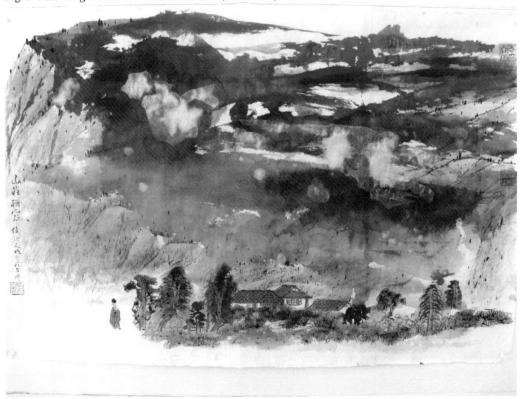

Fig 5-2

It began with a blank sheet of ordinary Chinese cotton paper, ordinary bottled ink, and tubes of Chinese water colors as seen in figure 5-2.

此圖起點是如 figure 5-2 樣，一張宣紙，瓶裝的墨汁及一些管裝的顏料。

Two Basic Approaches to Splash Ink-and-Color Painting 兩種畫法

Above all things, Hau is a firm believer and practitioner of "the heart and mind leading the hand." A frequent reminder from him is "to form the concept before the brush." He values painting with basic techniques and standard materials without relying on special tools or tricks.

There are multiple ways to approach splash ink and color. He demonstrated two of these approaches at Asilomar:

- Outline before splashing the color
 - Using a dry brush, do rough outlines of the forms (e.g. mountains, waterfalls).
 - This approach utilizes more fundamental techniques and generates richer Chinese painting effects.
- Splash before brush work
 - Wet the paper before splashing color/ink.
 - Wet-on-wet effects are achieved.
 - Outlines are added later to bring out form; the result has a more impressionistic feel.

示範之前，侯先生解釋了他的兩大原則。第一：意在筆先。下筆之前必須肚裏有底稿，心中有概念。第二：基本國畫手法及原料，無特技不取巧。

在阿斯樓馬，他示範了兩種潑彩之法。

先勾底後潑
　　　用乾筆先畫重點外形在乾紙，後潑彩。
　　　此法用傳統技巧較多。
先潑後勾勒
　　　先將畫紙打濕，再潑彩。
　　　濕破濕渲染。
　　　最後勾勒以顯形。

How to Decide which Method to Use 如何決定用那個方法?

Hau says that before painting, the artist needs to know not just the subject to be painted but the essence to be shown in the painting and the aspects to be emphasized. Knowing these will help determine the approach to use. To illustrate this idea, he provided an example of a mountain range painted with three different methods.

畫前必需先決定畫的主要氣勢及神韻何在。他以下面三種山脈畫法來解說這概念。

In figure 5-3 he used a broad brush loaded with ink mixed with water and a mixture of Antique Red and Purple. With a couple of traditional broad strokes he painted the mountain range below. Highlights in dark ink were added after the color strokes were done. Above this mountain range, he used ink with a dry-brush technique to paint the outlines of another set of mountains.

Fig. 5-3

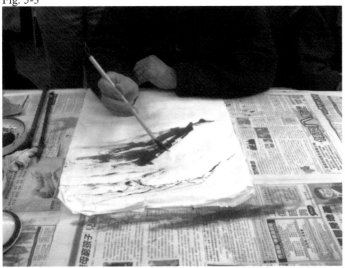

他用兩種方式畫了兩座山 (fig. 5-3, fig. 5-4)，
下面山是先下彩後加皴，上面山頭是先用乾筆畫出山勢再潑彩。

In figure 5-4 he then splashed the same Antique Red and Purple color mixed with water over the outlines of the higher mountain ranges.

Fig. 5-4

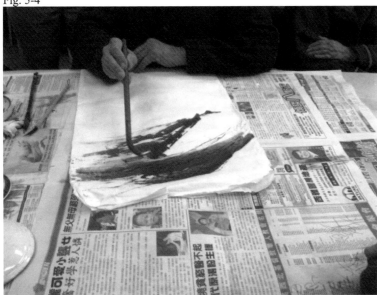

Finally, in between these two mountain ranges, he followed a traditional method by drawing an outline of the mountain first, then filling in the color for the mountain.

在兩山之間他用傳統先勾勒外形再填彩的方法又加了一座山。

Fig. 5-5

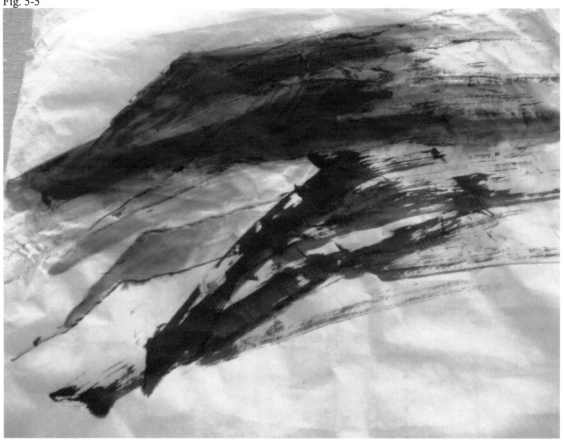

As you can see in figure 5-5, different methods captured different moods of the mountain range. The top range is gentle and moist, and the ink strokes diffuse softly into the body of the mountain. The middle range, though smaller and lighter, is very distinctive with its definitive borders. The bottom range is hard and massive with strong and prominent outlines to show the dynamic movement of the mountain. The decision of when to use the different methods depends on the emotion the artist wants to convey and the spirit of the scene he or she wants to depict.

由圖 5-5 可見每一畫法傳出不同的神態和情感。最上面的山柔和、濕潤、山紋若隱若現，中間的山脈雖小而顏色也輕但外形分明，下面的山雄壯堅硬、強魄有力。

從此簡例可見需先決定畫的神似之氣再選畫法。

Morning Clouds at a Mountain Estate was painted using the method that outlines before splashing the color. The step-by-step process is illustrated below.

山莊朝霞是先勾底後潑彩作畫的。我們將逐步示範解釋如下。

56

1. First, on a blank piece of paper, using a dry brush with light ink put down a few strokes representing the dynamic essence of the mountain range. 先用乾筆勾出山勢。

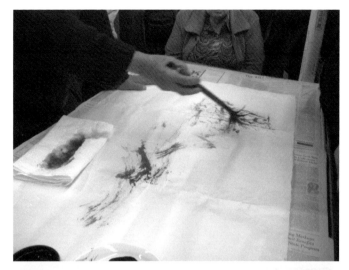

2. Use Indigo Blue as the base color for the mountain. Mix Indigo Blue with some water. Apply the color mixture first with broad splash-ink strokes; then splash the mixture across the page. 花青加水， 先用大筆潑彩畫出山形底色。

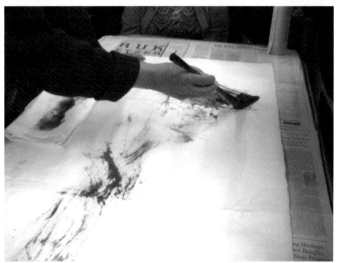

3. Mix Antique Red-Orange for the sky and splash it. 撥出紅天。

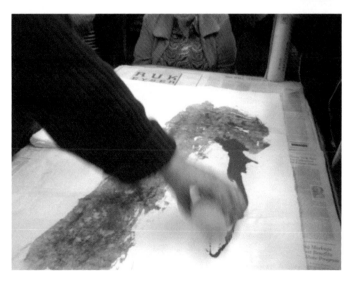

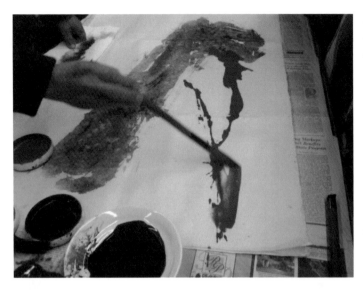

4. Where needed, use a wet brush with water for blending and creating variation in the clouds. 用水破彩加色韵。

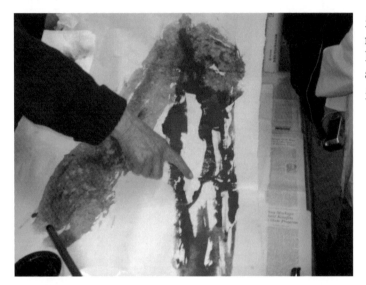

5. Splashing color creates a dynamic rhythm as shown in the photo to the left. This is more difficult to achieve using brush strokes. 潑彩產生活潑生動之氣。

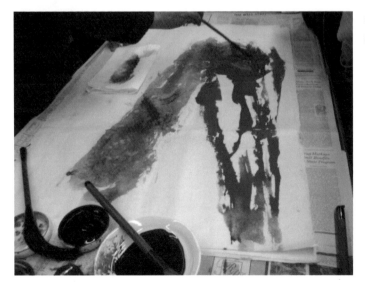

6. Add ink; connect the mountain and the sky. 加墨連天和山。

7. Add another layer of color made up of a mixture of ink and Indigo to the mountain range. 墨加花青，加潑一層顏色。

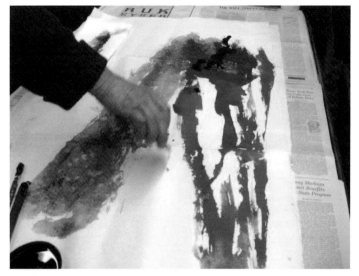

8. Brush in additional ink to build up the depth of the mountain. 大筆加墨色以顯出山脈厚重之氣。

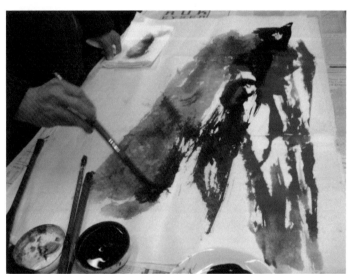

9. Add Burnt Sienna to the mountain range. 用褚石引進山坡顏色。

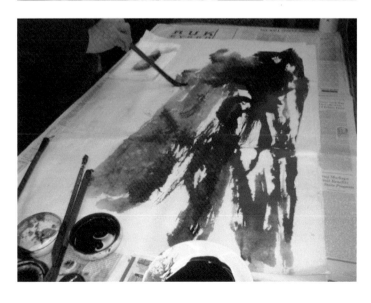

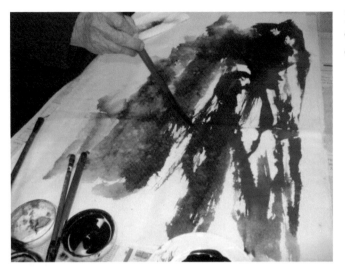

10. Use multiple layers of splash colors, blending to build complexity in color. 多層顏色流動成形加深度。

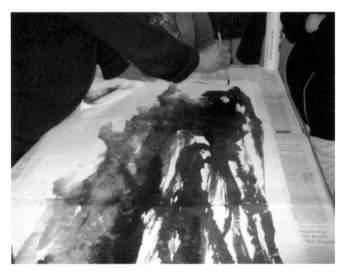

11. Add compositional details. Build shapes according to the rhythm formed by the blending of various colors. 添加佈局細節，因勢造形。

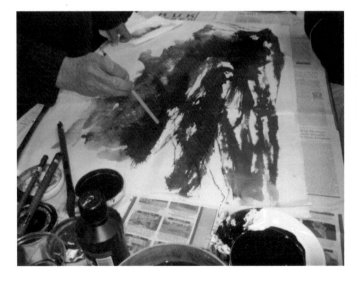

12. Add corresponding mountain outlines on the right side of the page for compositional interest and to balance the addition on the left. 在畫的右方也加山脈，相對呼應增加構圖趣味。

13. Stop and examine. 停筆查看. This is a critical step before taking a break and letting the painting dry. Check to see if you are happy with the color scheme and compositional flow.

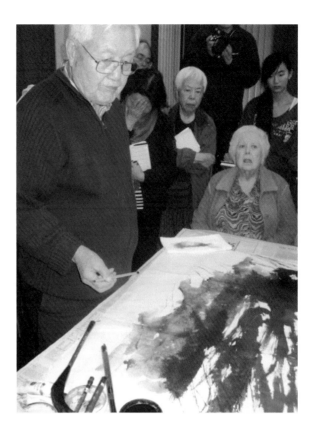

14. Hau, satisfied in the first stage of the work, decided to let the painting dry overnight before adding more content. 暫停等畫乾。

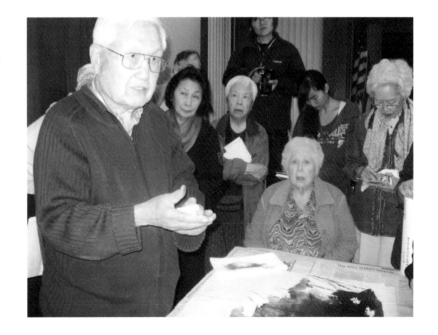

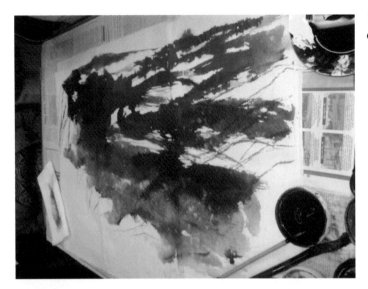

15. Observe the painting after drying overnight.　第二天畫乾了。

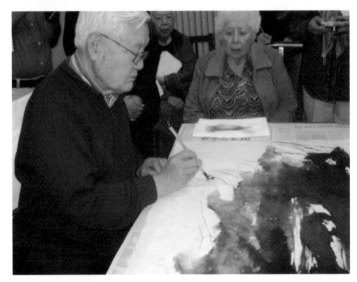

16. Add concrete details such as the trees and houses of a country village.
加構圖細節，樹，及房屋。

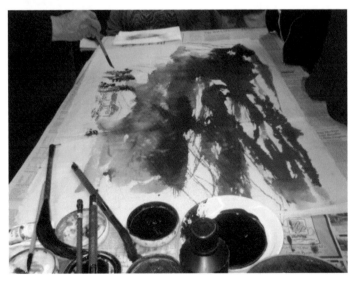

17. These elements enhance the look and feel of the Chinese painting.　加增國畫氣質。

18. Build up the hillside according to the rhythm inherent in the color/ink blocks. Let the painting dry. 因勢造形加山坡，之後，中飯暫停等畫乾。

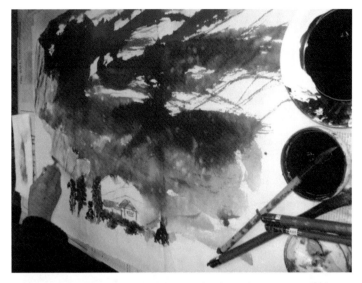

19. Hau decides to add Antique Spring Green to increase the liveliness of the painting. 又上一層彩增加生氣。

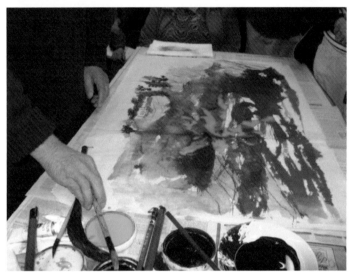

20. After the green has been splashed on the painting at the selected location, lift the paper to help the color expand and flow to the places desired. 以紙動而引起彩流。

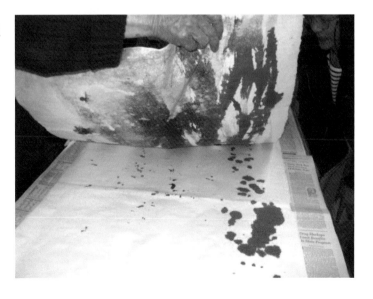

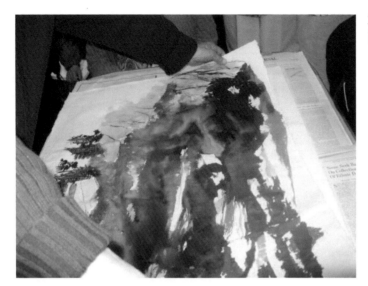

21. Adjust the flow of the color.
調整彩的流動之勢。

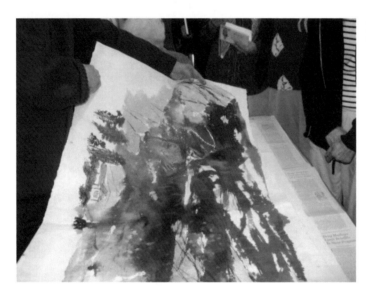

22. Further adjust the color flow to build the desired shape. 繼續以彩造形。

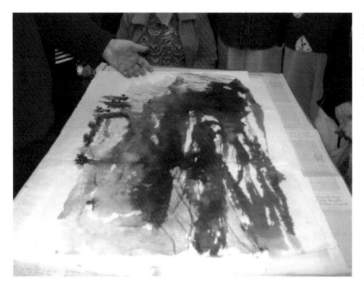

23. Hau examines the painting again and discovers that perhaps more green is needed in the mid-upper right for compositional balance.
查看構圖效果。
決定右方中上仍需綠彩。

24. Add additional green to the right.
填加綠彩。

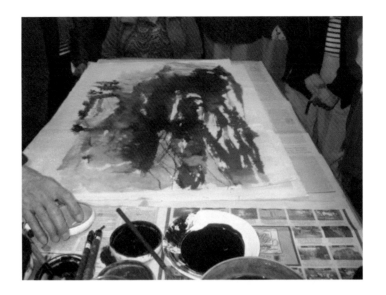

25. Move the paper around to help the
newly poured green flow to the areas
needed.　動紙以流彩。

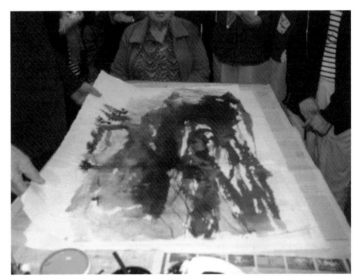

26. Look again.　Is the painting
satisfactory?　If satisfied, let it dry
overnight. 仔細觀看。　畫滿意嗎？
滿意的話讓畫過夜風乾。

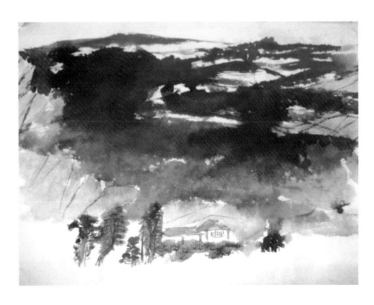

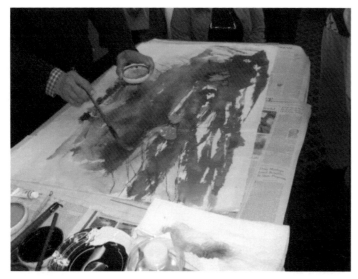

27. After the colors are set, add the sun's golden rays. Mix Holbein Gold color with the little red left in the unwashed dish from the night before to increase its richness. 最後上金色。
用隔夜沒洗之紅碟調色比用純金色好。

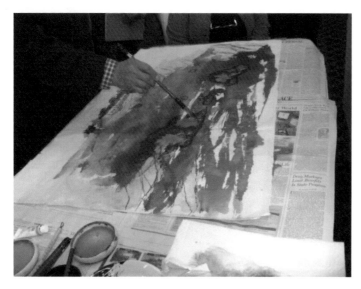

28. For this painting, gold was added after the other colors have dried to show blotching and a focused area of reflection for the sunshine. Other times, gold might be added wet-on-wet to obtain misty and blended effects. 底層乾了上金色成塊狀求效果。

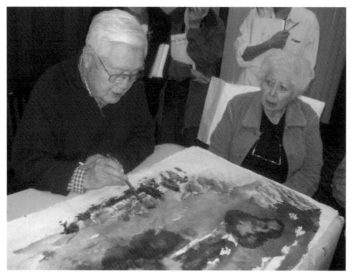

29. While the gold is drying, add highlights and moss dots according to the needs of the painting. 因畫之需小心收拓。

66

30. Nearly there. Pin the painting up and look at it carefully—have you missed anything? This is also a time to consider where on the painting you might want to write notations, sign it, and place your signature seal. This was how the painting looked at the end of the Asilomar workshop (see fig. 5-6). 畫稿幾近完成。仔細檢查並考慮提字蓋印何處。此時我們寫生會也結束了。

Fig. 5-6

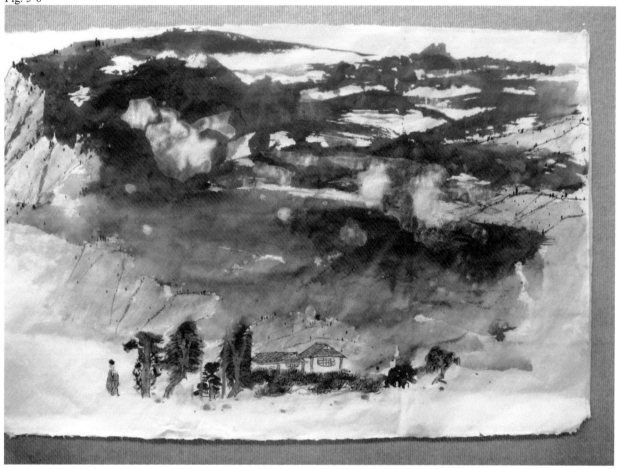

31. Hau made minor additions, named, and signed the painting at his studio in Los Altos.　Please compare the difference between the finished painting (fig. 5-1) and the one in fig. 5-6.　侯先生在他家中畫室完成此畫 fig. 5-1，提字，及蓋印。請比較 figure 5-1 與前頁 figure 5-6 不同之處。

Practice Makes Perfect 耐心苦習勤練，鐵鋤磨成針

The preceding pages record how Hau developed a splash ink-and-color masterpiece providing us some guidelines for applying the splash ink-and-color method.　Don't be frustrated if you are not able to master these methods right away.　When Mrs. Hau has seen students get discouraged with their painting, she often counsels us: "Be patient.　Your teacher has been painting for seventy-five years.　Keep practicing.　You will get there one day."　Let us share this encouragement and keep on painting.

前面幾頁可見侯先生潑彩步驟。有興趣者可以此為藍圖。但若短時不見效如意，請別氣餒。侯師母見我們畫不滿意失望之時常勸我們："別灰心要有耐心，你們老師畫了七十五年了。香字苦寒勤勞來，繼續畫，你們總有畫好的一天。"　共勉之。

Epilogue 後記

Looking for Innovation in His Nineties 九十求變

In his nineties, Hau has no intention of slowing down. In his painting, *Ten-Thousand Foot Green Cliff,* figure E-2, on the left edge and roughly one-third of the way down from the top of this painting, Mr. Hau used a seal, 九十求變, figure E-1, which means "looking for innovation at age ninety."

When asked about the seal 九十求變, Hau replied that landscape painting represents for him a devotion to and love of beauty and the land. He is not yet satisfied with what he has done and feels he has not yet captured the beauty of the land in his dreams. Although he is over ninety years old, he will continue to paint and to explore new ways to express that beauty and devotion.

Born in the eventful twentieth century, Hau was displaced from his home, traveled a great distance across oceans and continents, and lived though many upheavals in the world while also enjoying a bountiful artistic career. Now, at ninety-three—still full of energy, with firm legs, steady hands, clear vision, and a passionate heart—he continues his pursuit of innovation in his beloved art form. In describing Hau's life, art, and tireless search for innovation, curator Shu Jianhua quoted Goethe: "The golden tree of life springs ever green." Shu says, "Hau calls his home the Old Apricot Hall. Some of the old apricot trees no longer exist, but does not Mr. Hau himself resemble a mature and vigorous apricot tree?"

Although advanced in age, Hau enjoys good health, is optimistic, energetic, and full of drive. In 2008, during ASACA's November trip to Kunshan, China, Hau's energy and stamina outshone many of his students who are years younger. After the trip while many of us were still recovering from the journey and

雖已年過九十，侯先生仍然無意放慢脚步。在*千丈懸崖削翠* (fig. E-2) 這副畫的左邊中上之地，侯先生蓋了個"*九十求變*"(fig. E-1) 的印章。

當被問及"*九十求變*"這顆閒章的意義時他答"山水畫是我對藝術及家土愛好的投入。我自覺還沒把夢中美麗的田園畫出，雖已九十，我還是會繼續尋找新法畫下去。"

舒建華舘長在介紹侯先生 2009 年畫展前言中引用德國大詩人歌德的詩句 " 生命的黃金樹是碧綠的。". 舒舘長說："在波瀾壯闊的 20 世紀裏，侯先生行跡四方，西蜀江南，東洋西海，滄桑看罷，興盡丹青。如今九十三歲矣，依舊真力彌滿，脚不顫，手不抖，眼不花，還能創作丹青，渲染色彩宏富的八尺整紙的巨製，奇瑰磅礴、動人心魄。真是中國畫壇的曠古奇觀。侯先生一直把自己居所稱為 " 老杏堂"，如今那些杏樹雖已不存，但侯先生本身不就像一株蒼勁的老杏樹麼？順箸歌德的詩眼，這滿樹金黃的老杏，何嘗又不是滿目青翠呢？"

侯先生年高德厚，健康，樂觀，充滿活力及衝勁。2008 年 11 月 ASACA 的昆山之行，他走在比他年青許多的學生之前，活力及耐力都超越我們。昆山回來後當我們大多數人仍在調整時差，恢復旅行疲勞之時，他已開始作八尺的大畫。其中兩幅*采石磯* figure 4-5 及*雲山圖* figure 4-6 已於 2009 年 2 月在 Euphrat 博物舘展出。侯先生每早八點以前

adjusting our jet-lagged bodies, Hau was already busy at work with several of his large paintings. Among them, *Cai-shi Mountain* (fig. 4-5) and *Cloudy Mountain* (fig. 4-6) were completed and ready for exhibit at the Euphrat Museum in February of 2009. Hau is an early riser, often up before eight A.M. He is fond of painting at night when things are quiet and fewer distractions occur. He works long hours from morning to two or three A.M. at night, studying and painting with only one half-hour nap a day. Hau's dedication to art, diligence, and work are inspirational.

起床讀書作畫至深夜兩三點，中間只有一個三十分鐘的午睡。他的專心投注，勤勞及敬業精神是我們的典範。

Fig. E-1 *Looking for Innovation at Age Ninety,* 九十求變

Fig. E-2 *Ten-Thousand Foot Green Cliff,* 36"x72", 2009

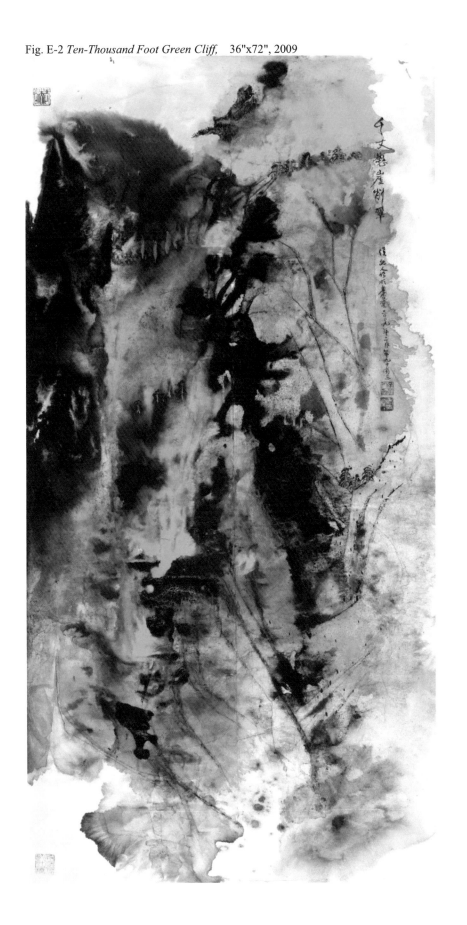

Appendix I 附錄

Chronology of Chinese Dynasties
中國朝代年代表

Qin 秦	221–207 B.C.
Han 漢	206 B.C.–A.D.220
Three Kingdoms 三國	220–265
Six Dynasties 六朝	265–589
Sui 隋	589–618
Tang 唐	618–907
Five Dynasties 五代	907–960
Song 宋	960–1279
Yuan 元	1279–1368
Ming 明	1368–1644
Qing 清	1644–1911

Appendix II 附錄

Visual Thinking Strategy (VTS) 視覺思考策略

VTS was included in this author's training as an outreach docent for the San Jose Museum of Art. The outreach docents employ VTS techniques when teaching Art Appreciation and Art History to children K-12 in the San Francisco Bay Area. We give the children four elements of art, namely, lines, shapes, color and texture—and then ask the children to

- make observations about these elements in the example artwork,
- notice how these elements are combined and interact with each other,
- state what story the artist might be telling or what is happening in the piece, and
- explain how what they observed in Step 2 led them to their conclusion in Step 3.

VTS engages learners in a rigorous process of examination and meaning-making through visual art. As a result, learners are encouraged to discover connections and relationships for themselves and in due course to improve their observation skills, evidential reasoning, and speculative abilities. I have seen VTS work effectively with children from kindergarten through high school. It gives them the ability to think visually and improved their ability to understand, analyze, and communicate about art.

筆者在美國加州聖荷西美術舘做講解員受訓時學到 VTS。講解員們用 VTS 方法教導灣區幼兒園到高中的學生，教他們文化欣賞及藝術史。收效極佳。我們給學生們四項藝術的元素'線、形、色及肌理'為工具並要學生們：

- 觀察藝術作品中這些元素是否存在
- 注意它們的組合及相對關係
- 探察並推惻藝術家所表達之故事或思想
- 以四元素相對的關係來解說第三步之結論

VTS 學生重復上面的四個步驟以視覺元素相對關係來思考及定論。經過一連串探視、觀察、推理、問答，往住有自發的心得。不僅能分析解答問題，並因此改進他們的觀察、探証、設想及推理能力。

Selected Bibliography 參考書目

Chen, Fan (陳凡). 1961. *Huang Binghong Collection of Art Theory(黃賓虹畫語錄)*. Hong Kong: The Shanghai Book Co. (上海書局).

Goepper, Roger. 1963. *The Essence of Chinese Painting*. United Kingdom: Percy Lund, Humphries & Co.

Hejzlar, Josef. 1980. *Chinese Watercolors*. London: Octopus Books Limited.

Kao, Arthur (高木森). 1999. *On My Own Paintings and Poems (自說自畫)*. Taiwan: Tung-hai University Publishing (東大圖書公司).

Liu, J.M. (劉繼明). 2003. *Paintings of Huang Binghong (黃賓虹畫集)*. Beijing: People's Art Publishing (人民美術出版社).

Zhang, X.J. (張曉江). 1997. *Selected Paintings of Pei-Jen Hau (侯北人畫集)*. Beijing, China: Foreign Language Press (外文出版社).

Zhao, Z.G. (趙宗概). 2008. *The Magnificent and Marvelous Scenes of Hou Bei Ren's Landscape Painting (造化瑰奇，侯北人山水画)*. Kunshan, China: Hau Bei Ren Art Museum (侯北人美術舘).

LaVergne, TN USA
15 August 2010
193413LV00010B